IMAGES
of America

GENEVA

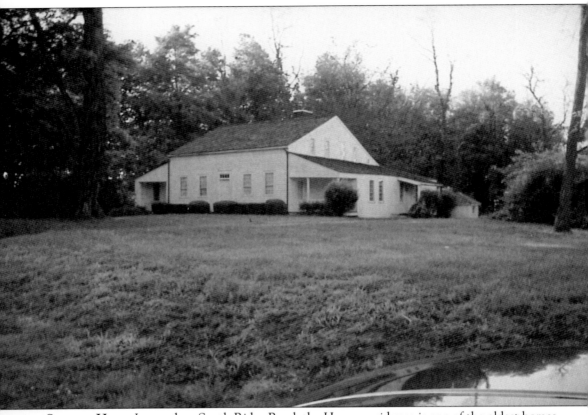

SHANDY HALL. Located on South Ridge Road, the Harper residence is one of the oldest homes in the Western Reserve. It was built in 1815 by Robert Harper, Col. Alexander Harper's youngest son of his eight children. He was a colonel in the War of 1812, as well as a farmer, lawyer, businessman, senator, and state representative. Over the next 20 years, Robert made additions to the home. Today the home has 17 rooms, the original bake oven, a cellar kitchen with a cooking fireplace, and a banquet room with early-19th-century wallpaper and a coved ceiling. It is currently a museum and is on the National Register of Historic Places. (Author's collection.)

On the cover: **CURRENT ARTHUR AND LLOYD'S BUILDING.** This early-1900s photograph is of the current Arthur and Lloyd's building. In 1879, D. Richards erected a monument (on the right) in memory of the soldiers and sailors who lost their lives during the Civil War. (Courtesy of the City of Geneva.)

IMAGES
of America

GENEVA

Susan Bradburn

ARCADIA
PUBLISHING

Published by Arcadia Publishing
Charleston SC, Chicago IL, Portsmouth NH, San Francisco CA

Printed in the United States of America

Library of Congress Catalog Card Number: 2007932658

For all general information contact Arcadia Publishing at:
Telephone 843-853-2070
Fax 843-853-0044
E-mail sales@arcadiapublishing.com
For customer service and orders:
Toll-Free 1-888-313-2665

Visit us on the Internet at www.arcadiapublishing.com

Dedicated in loving memory of my grandparents
Emory Anderson (1917–1991) and Elizabeth Anderson (1917–2007)
and my grandfather Edgar Brown (1910–1962)

CONTENTS

ACKNOWLEDGMENTS

This book has been possible because of the help, cooperation, and knowledge of many people to whom I am extremely grateful. I would like to thank James Miller III, Edna Turner, Dick Griffiths, Dave Johnson, Eddie Sezon, Georgette Allison, David Gale, Jennifer Brown, Pat Bowen, and the City of Geneva for their contribution of photographs and knowledge. I would also like to thank Rick Zack and the staff at Rapid Photo for copying and scanning the images used in this book. A special thanks to Matt Lomas and the Geneva Fire Department for the generosity of their time and resources.

I am extremely grateful to John D. Sargent for his Geneva on the Lake archival photographs and knowledge.

I wish to thank my editor at Arcadia Publishing, Melissa Basilone, for her help and guidance when needed.

INTRODUCTION

Geneva is located 45 miles east of Cleveland and is 55 miles west of Erie, Pennsylvania. Geneva is the self-proclaimed "best location in the best location in the nation." There is no evidence that Native Americans lived in Geneva, although they did roam the area. The Geneva area was first surveyed by Moses Cleaveland in 1796. Owned by the Connecticut Land Company, the area was known as the Western Reserve. The limits of Ashtabula County were defined in 1807, and Ashtabula County was organized on January 22, 1811. The city of Geneva was established from Geneva Township, and Geneva Township was part of Harpersfield Township until 1816.

Several prominent former Geneva residents are included herein. Ransom E. Olds, who was born in Geneva on June 3, 1864, founded the Olds Motor Vehicle Company in Lansing, Michigan, on August 21, 1897. Platt Rogers Spencer, the creator of a popular type of cursive handwriting called Spencerian penmanship died in Geneva on May 16, 1864. Freeman Thorpe, a famous American painter, was born in Geneva in 1844. He painted many portraits of famous political figures, including Robert E. Lee, James Garfield, Abraham Lincoln, Grover Cleveland, and Ulysses S. Grant. Emy Coligado, born on June 5, 1971, in Geneva, has had a recurring role as Emmy on *Crossing Jordan* and as Piama on *Malcolm in the Middle*. She has also guest starred as a student on *ER*, Claudia on *Everybody Loves Raymond*, Rochelle on *Fillmore!*, and Janelle Duco on *Grey's Anatomy*. Major-league pitcher Brian Anderson graduated from Geneva High School in 1990. He attended Wright State University from 1991 to 1993. He pitched for the California Angels from 1993 to 1994, the Cleveland Indians from 1995 to 1997, the Arizona Diamondbacks from 1998 to 2002, the Cleveland Indians again in 2003, and the Kansas City Royals from 2004 to 2005. In 2006, he signed to play for the Texas Rangers.

Walter L. Main was born in Lodi in 1862 and was a Geneva resident for most of his life. In his 20s, Main became the sole owner of a 25 horse wagon circus. He traveled all over the country and Canada. In the late 1890s, the circus animals and equipment were housed in the original Geneva Metal Wheel Company buildings. He retired in 1937 and spent his days in Geneva. He died on November 29, 1950, at the age of 88 and was buried in Pittsburgh. The Walter Main road was named after him.

This photographic history of Geneva mainly covers the time from when the first settlers arrived to the area in the early 1800s to the present day. The area covered includes the city of Geneva, Geneva on the Lake, and Harpersfield Township.

One

GENEVA

In the late 1820s, Geneva had spread from South Ridge Road to North Ridge Road (which is now U.S. Route 20). Geneva continued to grow, and several homes and buildings were erected. With a population of approximately 1,500, Geneva became an incorporated village in 1866. Dennis Thorp served as the first mayor.

Forest City Electric Works opened in Geneva in 1890, and seven years later, the village was illuminated by electric streetlights. By 1900, the village had a population of approximately 3,000. There were two clothing stores, two grocery stores, two hardware stores, three jewelry stores, and two drugstores. In the early 1900s, Geneva became known for its automobile industry. The Geneva Steamer was the first car manufactured here in 1901. The company was sold to the Colonial Brass Company three years later. The Ewing Taxi was manufactured in 1908 by E. L. Ewing. Two years later, General Motors bought the company and moved it to Flint, Michigan. The H. B. Young Motor Company of Cleveland relocated its business to Geneva. It produced the Little Giant, which was a truck line. Approximately 18 months later, the business was sold.

On April 3, 1958, Geneva became a city, with Robert C. Salisbury as the first city manager. Geneva was Ohio's 1,148th city and the third city in Ashtabula County. The city held a two-day celebration called City Days. Ohio state senator C. Lee Mantle and state representative Howard Shayler attended the event.

The first annual Grape Jamboree was held on September 19 and 20, 1964, in celebration of the harvesting of grapes and was sponsored by Fischer-Spiegel, the Tri-County Grape Growers Association, and the city's merchants. Since the festival was a huge success, the Grape Jamboree officials announced that they would continue with the festival annually. Several events at the festival have become very popular each year, including the parades on Saturday and Sunday, the grape-stomping contest, a craft fair, an art show, live music at the grandstand, many concession stands, and the crowning of Miss Grapette. The Grape Jamboree continues to be held annually in September.

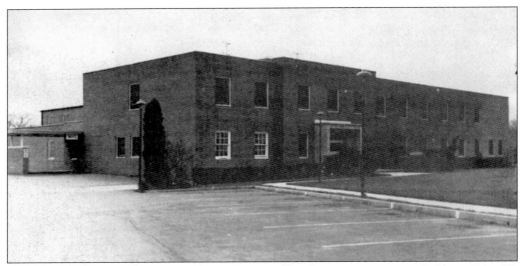

GENEVA MEMORIAL HOSPITAL, 1950s. A groundbreaking ceremony was held on June 28, 1949, for the Geneva Memorial Hospital. Sizable donations from local businessmen and pledges from Geneva citizens totaled over $100,000. This amount was not enough, and federal aid was requested and later granted. After many delays, in the spring of 1951, the opening was officially announced by R. C. Patterson, board of trustees president. (Author's collection.)

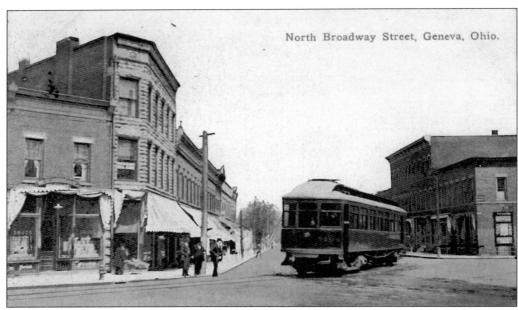

North Broadway Street, Geneva, Ohio.

NORTH BROADWAY, LOOKING NORTH, EARLY 1900s. The Cleveland Painesville and Ashtabula Electric Interurban Transportation Company laid the iron rails in Geneva in 1903. Many residents would take trolley rides to Cleveland. Twenty-three years after it began, the trolley made its last run on February 24, 1926. (Author's collection.)

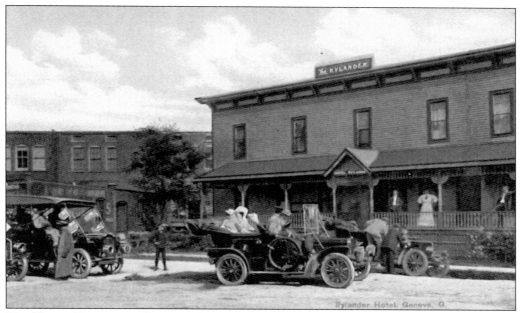

THE HOTEL RYLANDER, CHARLES RYLANDER, PROPRIETOR. Located on Station Street, which is now Depot Street, the Hotel Rylander was later converted to VFW Post No. 06846 in 1946. The building was later torn down, and a new VFW post building was constructed in its place. (Author's collection.)

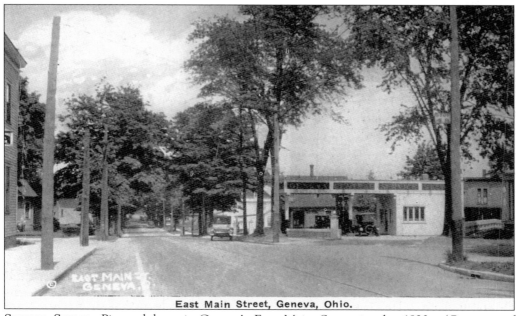

East Main Street, Geneva, Ohio.

STREET SCENE. Pictured here is Geneva's East Main Street in the 1920s. (Courtesy of Edna Turner.)

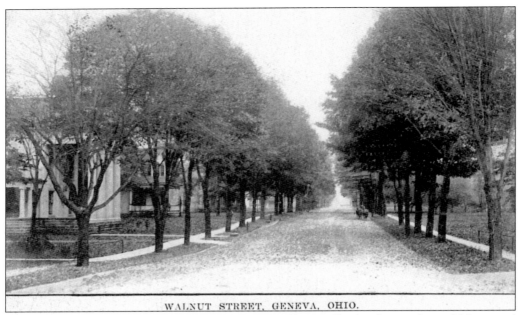

WALNUT STREET, GENEVA, OHIO.

WALNUT STREET, LOOKING EAST, AROUND 1907. Eventually the dirt roads would be paved and trees would be cut down to make room to build more houses as Geneva continued to grow. (Courtesy of Edna Turner.)

One of the pretty homes of Geneva, Ohio.

HOME ON WALNUT STREET, 1907. This home was owned by A. Tyler. The Peoples Church bought the home, and the congregation moved into it on March 1, 1953. It still stands today and is used as an apartment building. (Courtesy of Edna Turner.)

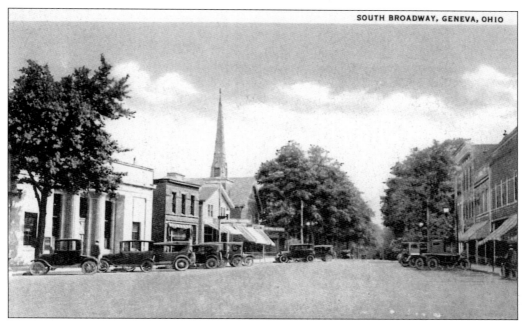

SOUTH BROADWAY, LOOKING SOUTH, AROUND 1930. The stores were busy, and Geneva was growing. Just a few years earlier, village councilmen passed legislation to pave the downtown major streets. Paved roads were necessary for more automobiles to be brought into the village. More automobiles meant greater prosperity. (Courtesy of Edna Turner.)

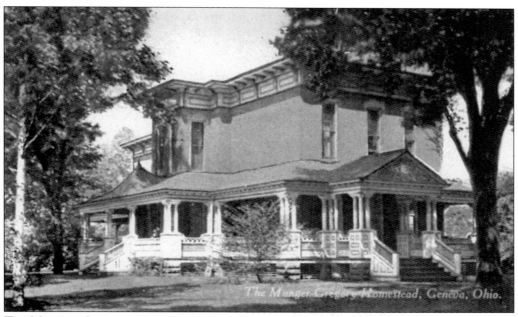

THE MUNGER GREGORY HOMESTEAD IN A POSTCARD VIEW. Built in the late 1880s and located on North Broadway, this house still stands today. The house is hardly recognizable because of the several changes that have been made to it. The biggest changes include the porch being removed and an addition being built on the south side. (Author's collection.)

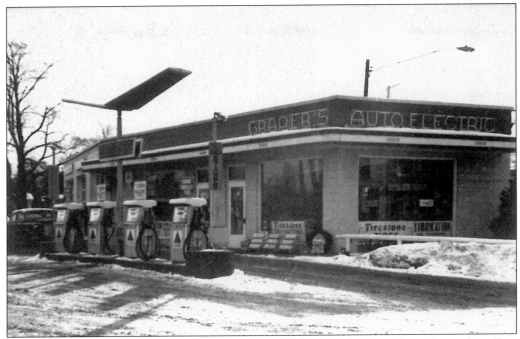

GRAPER'S AUTO ELECTRIC SERVICE. Graper's opened in the 1930s and was located on East Main Street. It later closed, and the building was torn down. (Courtesy of James Miller III.)

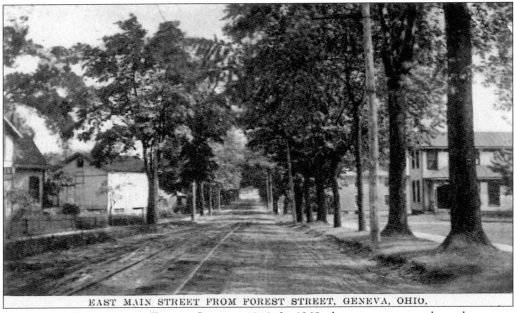

EAST MAIN STREET FROM FOREST STREET, GENEVA, OHIO.

EAST MAIN STREET FROM FOREST STREET, 1910. In 1868, the trees were set along the streets by the village council. (Courtesy of Edna Turner.)

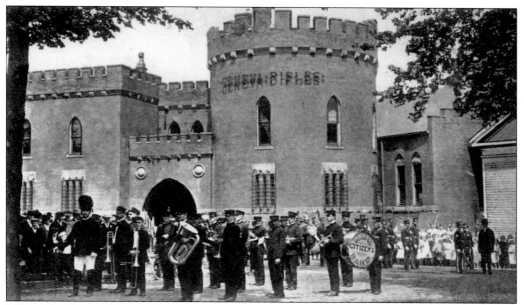

MEMORIAL DAY, 1904. The armory, home to the Geneva Rifles, was built in 1896 for the Company E, 5th Regiment, Ohio National Guard. In front of the building is the Geneva Citizens Band. Many years later, parts of the building were torn down, and after receiving a face-lift, it served as the Geneva Municipal Building until 1988. It is now used as the Geneva Recreation Center. (Courtesy of Edna Turner.)

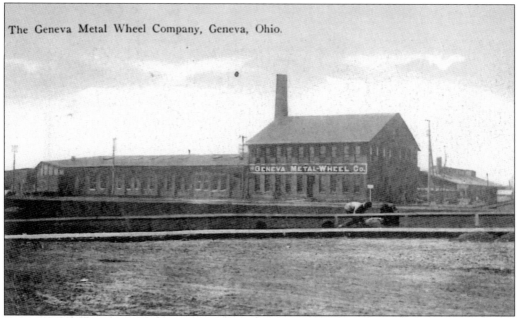

The Geneva Metal Wheel Company, Geneva, Ohio.

THE GENEVA METAL WHEEL COMPANY. The Geneva Metal Wheel Company moved from New London to Geneva in 1901. It was the largest manufacturer of steel wheels and industrial pneumatic tires. It employed approximately 30 employees in 1910. H. A. Ford served as president of the company. (Courtesy of Edna Turner.)

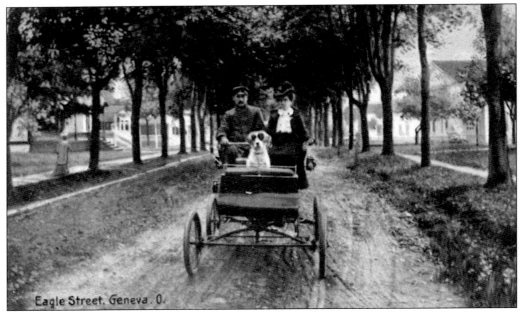

EAGLE STREET, 1908. This view of Eagle Street appeared on a postcard. (Author's collection.)

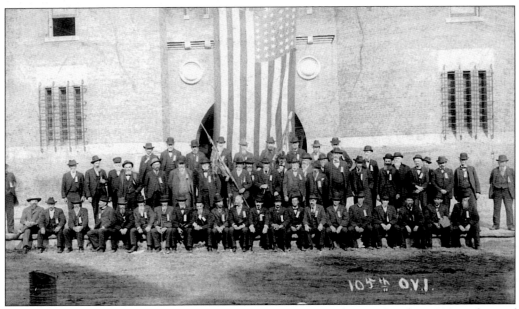

THE 105TH OHIO VOLUNTEER INFANTRY. This picture was taken in October 1898, in front of the Geneva Armory. (Courtesy of the City of Geneva.)

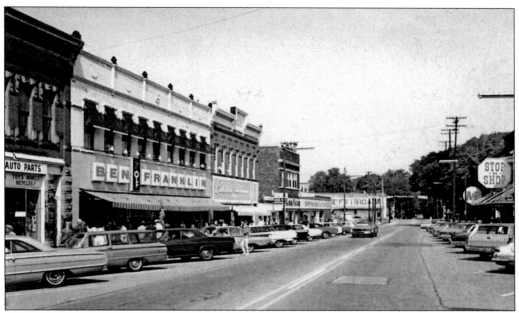

NORTH BROADWAY, LOOKING NORTH, THE 1960S. The city budget was approved in 1960, and downtown received 33 high-lumen fluorescent streetlights. (Author's collection.)

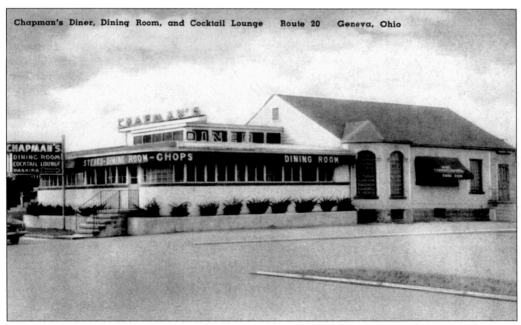

CHAPMAN'S DINER. The air-conditioned dining room and cocktail lounge of Chapman's Diner are seen here in the 1950s. The diner was located on West Main Street. (Courtesy of Edna Turner.)

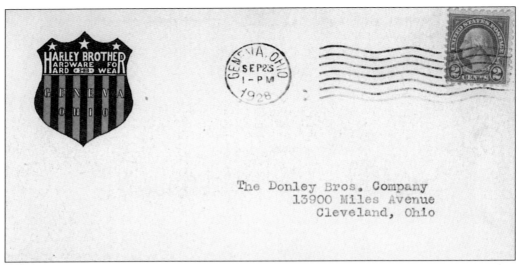

Envelope Dated September 23, 1928. The return address on this envelope is "Harley Brother Hardware for Hard Wear." (Author's collection.)

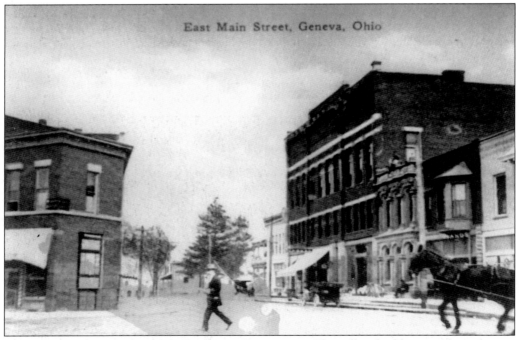

Broadway and Main Street, Looking East, 1912. The tallest building on the right was owned by Jennie Munger Gregory, and the building farther down to the left of it was owned by Western Reserve Properties. Both were destroyed by fire on November 7, 1958. The damage was estimated at approximately $200,000. A few days later, Gregory made a sizable contribution to the Geneva Fire Department to purchase modern fire equipment. One of the items purchased was a multivariable deluge fire nozzle. A few months later, the property was sold to the Geneva Federal Savings and Loan Association. (Courtesy of James Miller III.)

OLD MILL WINERY. Located on South Broadway, this building was constructed sometime before 1864, and the milling business was started by J. E. Goodrich and Company. The building was the first dedicated by the Ashtabula County Historical Society in the city of Geneva. (Author's collection.)

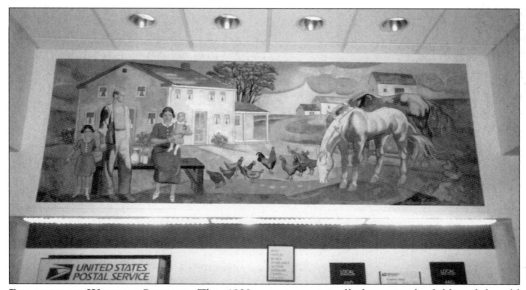

PAINTING BY WILLIAM SOMMER. This 1939 painting originally hung in the lobby of the old post office, which was located on the corner of South Broadway and Park Street. Currently it is hanging in the new post office at 1041 South Broadway. (Author's collection.)

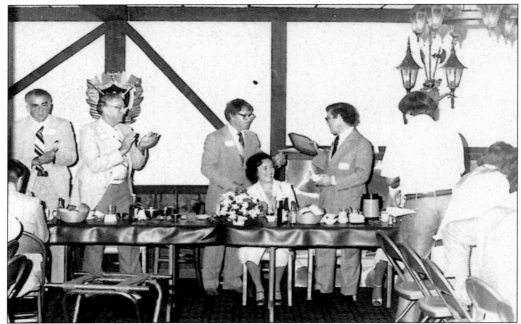

THE FIRST ANNUAL MILLER FOUNDATION AWARD DINNER, AUGUST 28, 1980. The winner of the award was Seymour S. Stein, Ph.D., P.E. The dinner was held at the Geneva Inn on State Route 534 by Interstate 90. (Courtesy of James Miller III.)

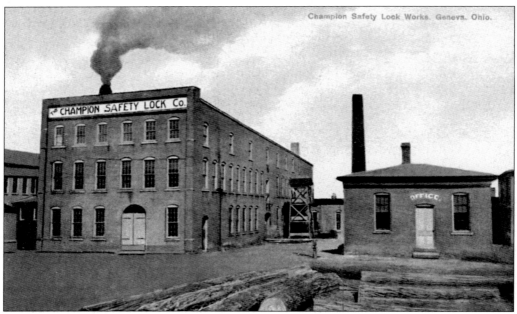

THE CHAMPION SAFETY LOCK COMPANY. Originally established in Cleveland in 1883, the Champion Safety Lock Company moved to Geneva around 1903. It was the manufacturer of fine builders' hardware and employed about 150 people. (Author's collection.)

ENTRANCE TO MOUNT PLEASANT CEMETERY IN A POSTCARD VIEW. The Mount Pleasant Cemetery is located on South Ridge Road. (Author's collection.)

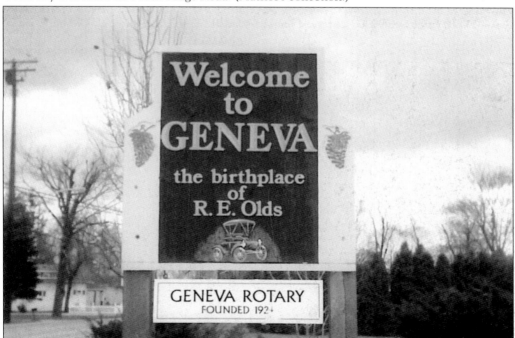

WELCOME TO GENEVA. This sign was located on the corner of North Broadway (State Route 534) and Roosevelt Drive. Other signs identical to this one can be found defining the city limits. Ransom E. Olds was born in Geneva on June 3, 1864. He founded the Olds Motor Vehicle Company in Lansing, Michigan, on August 21, 1897. He died on August 26, 1950, at the age of 86. (Author's collection.)

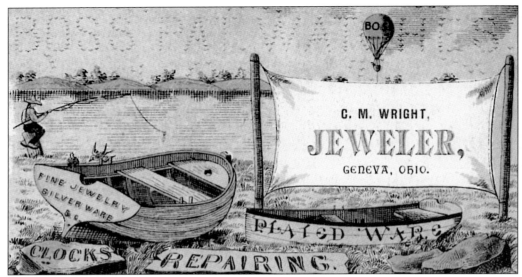

C. M. Wright Jeweler Card, 1920s. C. M. Wright was a dealer in Boss watches. This was just one of many jewelry stores that Geneva would see come and go. (Author's collection.)

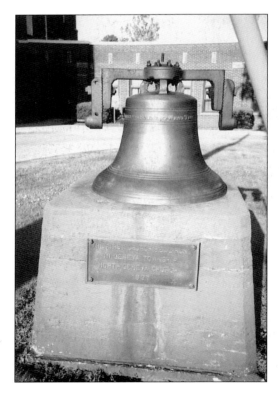

The First Church Bell. The bell that was rung in Geneva Township in 1837 at the North Geneva Church is now on display beside the Geneva Methodist Church on South Broadway. (Author's collection.)

The Chas. Stewart Company 1943 Matchbook Cover. The Chas. Stewart Company was located on North Broadway. (Author's collection.)

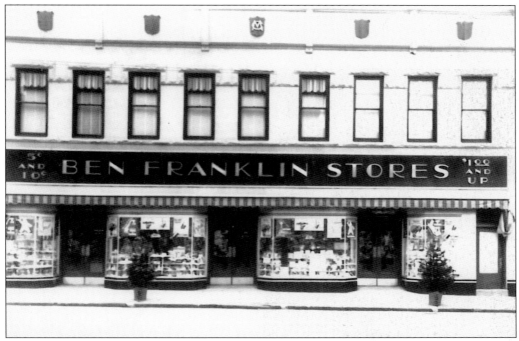

The Ben Franklin Store. Originally the Hawes and Jackson Variety Store, operated by Charles Hawes, this store was in business for about five years before Hawes sold it to E. L. Swanson and his wife. The store closed for a period of time before it opened back up as the Ben Franklin store on February 11, 1939. In the 1960s, Glenn Snyder and his wife took over ownership of the store. The storefront was changed, and new doors and new plate glass windows were installed. It later closed, and Rapid Photo now occupies the building. (Courtesy of James Miller III.)

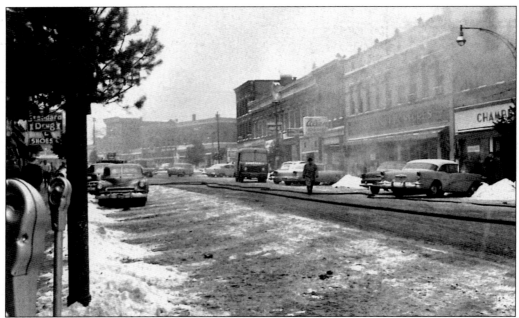

DOWNTOWN GENEVA, WINTER 1959. This view is of North Broadway looking south. Many changes have been made since 1959. Many businesses have closed, and others have opened up in their places. Parking meters have been removed and new streetlights installed. (Courtesy of Dick Griffiths.)

T. J. Wood & Co.,

MANUFACTURERS AND DEALERS IN

FURNITURE,

Picture Frames, Chromos and Fancy Goods.

Please call at our rooms and examine Goods and Prices. We deal in

STRICTLY FIRST-CLASS GOODS.

GENEVA, OHIO.

T. J. WOOD AND COMPANY, FURNITURE DEALER, VICTORIAN TRADE CARD, 1880S. T. J. Wood and Company manufactured and dealt in furniture, picture frames, chromos, and fancy goods. (Author's collection.)

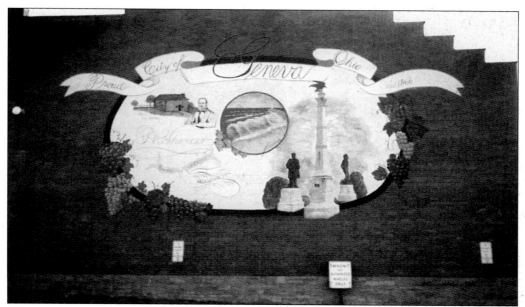

MURAL. This mural can be found on the east side of the Geneva Recreation Center. (Author's collection.)

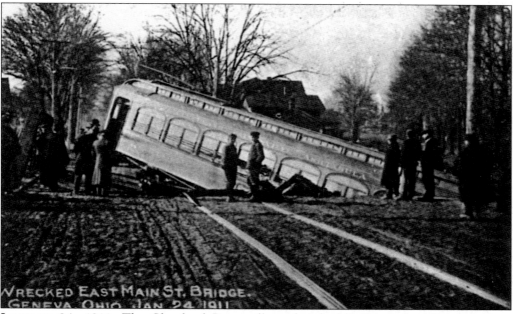

JANUARY 24, 1911. The Cleveland Painesville and Ashtabula Limited trolley picked up passengers at Broadway and Main Street headed to Ashtabula. When the trolley was heading east on Main Street approaching the bridge (at the end of what is now Woodlawn Street), it suddenly came off the tracks and plunged into the water of Cowles Creek. There were no injuries to the 10 riders, although they were shaken up. The cause of the accident was never determined, although it was believed that the tracks were somehow dislocated, possibly due to a sudden thaw. (Author's collection.)

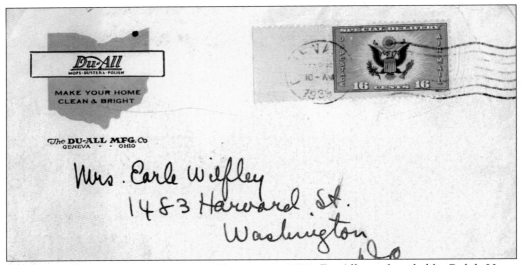

DU-ALL MANUFACTURING COMPANY ENVELOPE, 1939. Du-All was founded by Ralph Henn in 1919 in Cleveland. The company moved to Geneva in 1928 and was located on North Eagle Street. It manufactured 750,000 wet mops and dust mops annually. (Author's collection.)

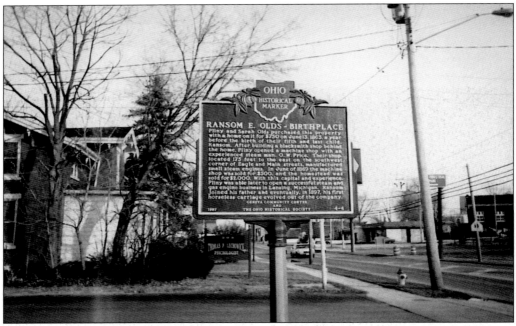

OHIO HISTORICAL MARKER, 217 WEST MAIN STREET. Ransom E. Olds's parents, Pliny and Sarah Olds, bought this property on June 13, 1863, for $750. On the property was a single-family home, where Ransom was born. Pliny built a blacksmith shop behind the home and opened up a machine shop, manufacturing small steam engines. Six years after purchasing the property, Pliny and Sarah sold the machine shop for $500 and the home for $2,000. (Author's collection.)

SOUTH BROADWAY, GENEVA, OHIO.

SOUTH BROADWAY, LOOKING SOUTH, 1910. In 1911, the soldiers and sailors monument (on the right) would be moved. South Broadway was one of the first streets to be paved in Geneva along with North Broadway and East and West Main Streets. (Courtesy of Edna Turner.)

DOWNTOWN GATHERING, LATE 1920S. This photograph was taken at the intersection of Main Street and Broadway in the center of town. (Author's collection.)

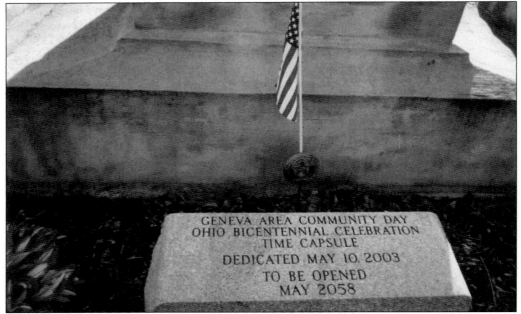

Time Capsule. The Geneva area community day, Ohio bicentennial celebration time capsule was dedicated on May 10, 2003, and is to be opened in May 2058. The capsule is located on the corner of South Eagle Street and Park Street at the base of the soldiers and sailors monument. (Author's collection.)

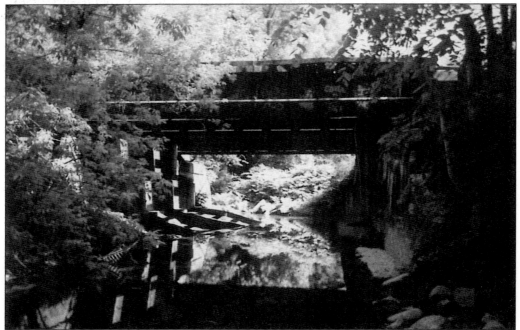

The CSX Railway Bridge. The CSX railway bridge spans across Cowles Creek. (Author's collection.)

DOWNTOWN GENEVA. This is a view of North Broadway looking south on Thanksgiving Day, November 23, 2006. The downtown businesses are closed for the holiday. The buildings have been very well maintained throughout the years. (Author's collection.)

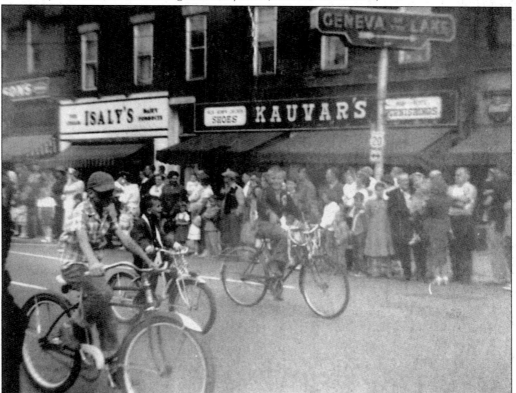

WEST MAIN STREET (STATE ROUTE 20). Downtown Geneva is awaiting the City Days parade in 1958. Isaly's dairy company and Kauvar's clothing store can be seen in the background. These stores have gone out of business, and the old Geneva on the Lake sign is no longer there. (Courtesy of the Rees family collection.)

WE GROW THEM LIKE THIS
AT GENEVA. O.

POSTCARD, 1915. In the early 1900s, Geneva's fertile soil brought a large number of farmers to the area. In the past, the area ranked among the leaders in vegetable production. (Author's collection.)

Near Geneva, Ohio

POSTCARD, 1912. The Geneva area has always been made up of a lot of farmland. (Author's collection.)

THE FIRST BAPTIST CHURCH, NOW THE UNITED CHURCH. In 1949, the Congregational and Baptist Churches voted to merge to form one church, which they named the United Church. In 1961, the front of the church was remodeled and a three-story educational addition was built. (Courtesy of Edna Turner.)

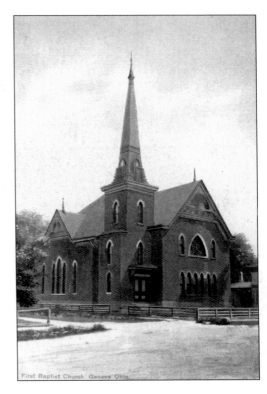

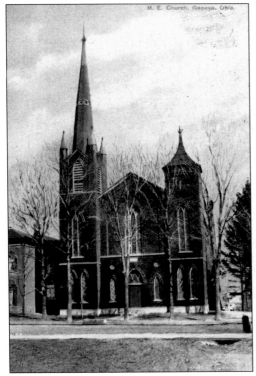

METHODIST CHURCH. Several changes have been made to the Methodist church, built in 1866, throughout the years. A brick parsonage was built in 1877. In 1950, a new entrance was built, new pews replaced the theater-type seats, a new lighting system was installed, and the church was newly decorated. The church is still in use today and is located on South Broadway. (Courtesy of Edna Turner.)

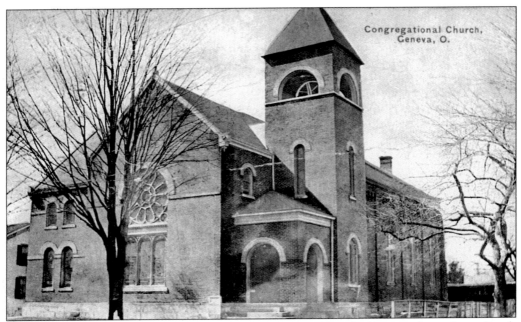

Congregational Church, Geneva, O.

GENEVA CONGREGATIONAL CHURCH, AROUND 1913. This building is located on South Eagle Street and has been occupied by the Masonic temple hall since 1954. (Courtesy of Edna Turner.)

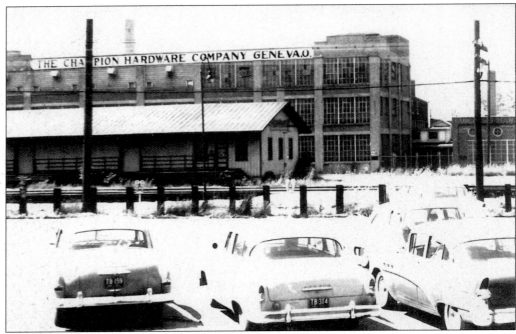

THE CHAMPION HARDWARE COMPANY GENEVA, O.

CHAMPION HARDWARE COMPANY. The Champion Hardware Company closed in the early 1950s. In 1958, the buildings were sold to the Great Lakes Automotive Company, which is a subsidiary of the Great Lakes Tractor Company. (Courtesy of James Miller III.)

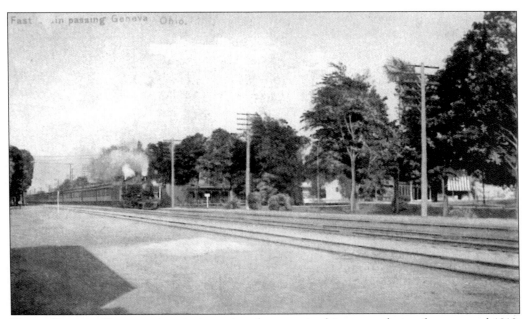

TRAIN PASSING GENEVA. A train is passing the town in this postcard view from around 1910. (Author's collection.)

EAST MAIN STREET, 1908. This photograph was taken looking east from the end of Railroad Street (now Woodlawn Street). (Courtesy of Edna Turner.)

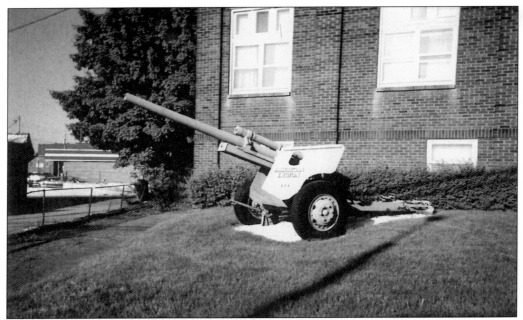

AMERICAN LEGION ARTILLERY CANNON AFTER WORLD WAR II. The American Legion George Call Post has been located on the corner of South Eagle Street and Park Street since 1931. It was named after the first Genevan who was killed in World War I, George Call. (Author's collection.)

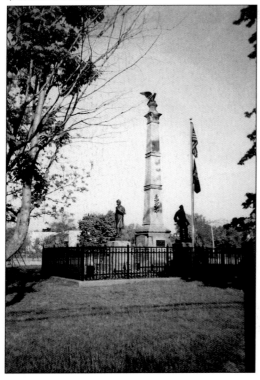

THE SOLDIERS AND SAILORS MONUMENT. Built in 1879, the soldiers and sailors monument was located on the corner of West Main Street and South Broadway. On October 2, 1911, the village council passed an ordinance to remove the monument for safety reasons. It was moved to the corner of Eagle Street and Park Street in the school yard. A. W. Loveland moved the monument for $280 and guaranteed that he would move it without defacement, damage, or breakage. (Author's collection.)

PLATT ROGERS SPENCER GRAVE SITE. This grave site is in the Evergreen Cemetery on Eastwood Street. Platt Rogers Spencer was born on November 7, 1800, in East Fishkill, New York, and was known as the "Father of American Penmanship." In 1810, he and his family arrived in Ashtabula County. He eventually taught writing in the schools around the county. In 1828, he married Persis Duty, who was also a teacher. They made Geneva their home, and in 1838, Platt was elected as the treasurer of Ashtabula County, where he remained in office for 12 years. The Spencerian penmanship was a popular type of cursive handwriting developed by Spencer and was eventually taught at schools across the nation. Spencer produced a series of books, of which he sold over a million copies. His wife, Persis, died in 1862, and Spencer died on May 16, 1864. (Author's collection.)

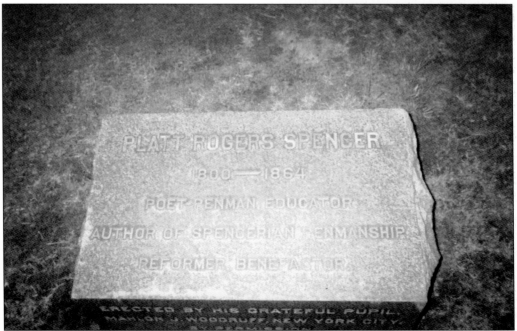

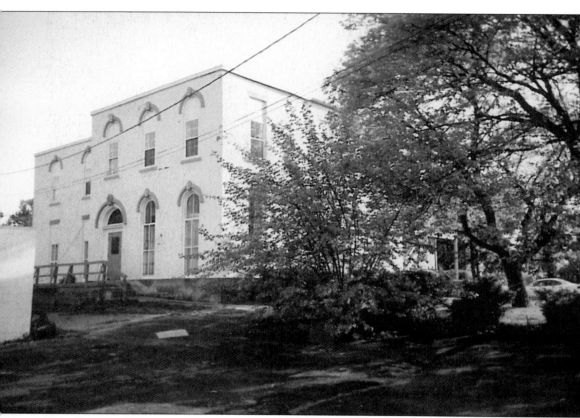

THE TUTTLE HOUSE. Located on South Broadway, this building was constructed in 1873, originally as a residence, then converted to a hotel after the Tuller House was destroyed by fire. It was named the Tuttle House and later renamed the Broadway Inn. The Tuttle House was where distinguished citizens and guests met for good living and entertainment. At the time, the building was modern throughout, a toilet and bath on each floor, a hot water heating system, electric lights, and also Aqua-Vita Mineral Spring water connected to it. It was advertised that it had the finest dining between Cleveland and Buffalo and had seated as many as 150 people. The Tuttle House also had a bowling alley and a billiard parlor and could accommodate up to 75 overnight guests. The building was managed by E. L. Zimmerman and owned by P. W. Tuttle. It is now used as an apartment building. (Author's collection.)

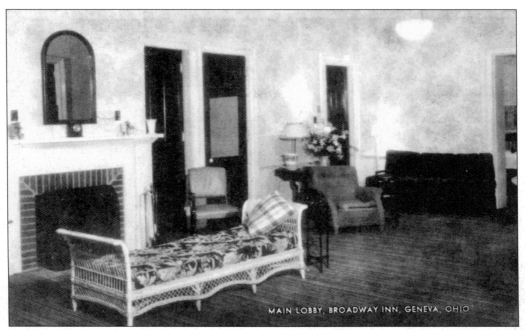

MAIN LOBBY, BROADWAY INN, GENEVA, OHIO

MAIN LOBBY. This is the main lobby of the Broadway Inn. (Courtesy of the John D. Sargent Geneva on the Lake collection.)

TULLER HOUSE ADVERTISEMENT, 1860S. Located on North Broadway and built in 1869, the Tuller House and Livery was Geneva's leading hotel at the time. In 1892, a devastating fire destroyed most of North Broadway, including the Tuller House. (Author's collection.)

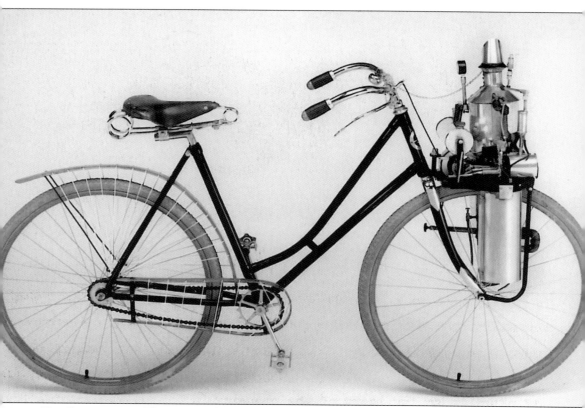

THE STEAMCYCLE. The steamcycle was one of America's first motorcycles, and it was manufactured at the Geneva Cycle Company in 1896. Its top speed was 16 miles per hour. (Courtesy of the City of Geneva.)

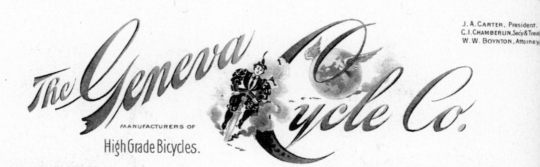

J. A. CARTER, President.
C. I. CHAMBERLIN, Sec'y & Treas
W. W. BOYNTON, Attorney

The Geneva Cycle Co.

MANUFACTURERS OF

High Grade Bicycles.

Geneva, Ohio. 1/5/97.

L. J. Southworth, Receiver,

 Plymouth, Ind.

Dear Sir:-

 I note by the "Referee" the order for sale of the effects

of the Plymouth Cycle Co. The writer is looking for a Factory to

buy, i. e. the machinery, tools and merchandise, for cash if at a

satisfactory price. Will you please give me full information, and

if possible an inventory of the property.

 Your early attention, will oblige,

 Yours very truly,

(F) Ans 1/7/97 J. A. Carter

LETTER FROM J. A. CARTER, PRESIDENT OF THE GENEVA CYCLE COMPANY. This letter is dated January 5, 1897. The Geneva Cycle Company opened in 1894, and in 1899, it produced 15,000 bicycles. Geneva residents would have cycling parties where large groups of people would ride their Geneva bicycles to Geneva on the Lake. The company later closed its doors and moved to Toledo. (Author's collection.)

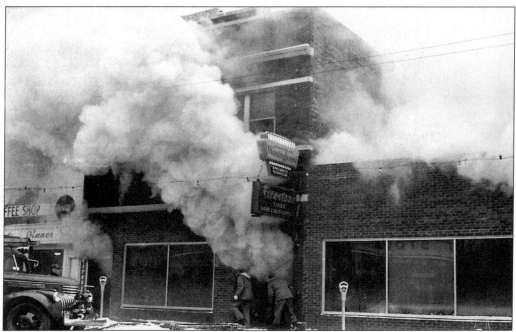

FIRE AT GRIFFITHS HOME AND AUTO SUPPLY, JANUARY 7, 1959. Griffiths Home and Auto Supply, located on North Broadway, was gutted by a fire, which evidently started in the basement. Geneva, Saybrook, and Geneva on the Lake Fire Departments fought the smoke and fire for nearly 12 hours. In the basement there were tires, causing black smoke and making it difficult for the firefighters to extinguish the fire. The damage was estimated at $70,000. (Courtesy of Dick Griffiths.)

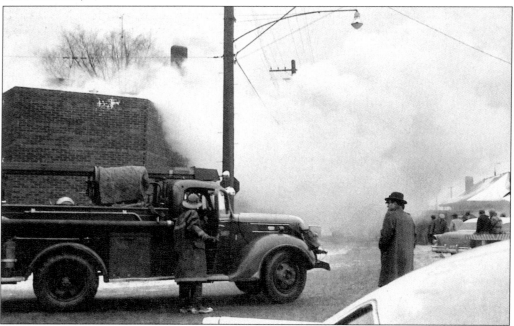

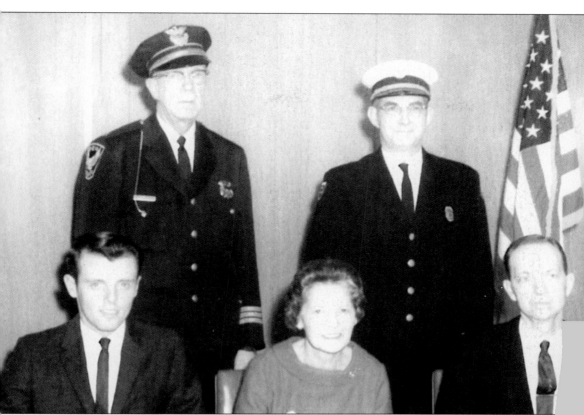

GENEVA CITY DEPARTMENT HEADS, 1968. From left to right are (first row) street superintendent W. H. Saunders, city clerk F. Telling, and chief operator of the wastewater system J. L. Schack; (second row) chief of police L. L. Sprague, and Fire Chief R. D. Bancroft. (Courtesy of the City of Geneva.)

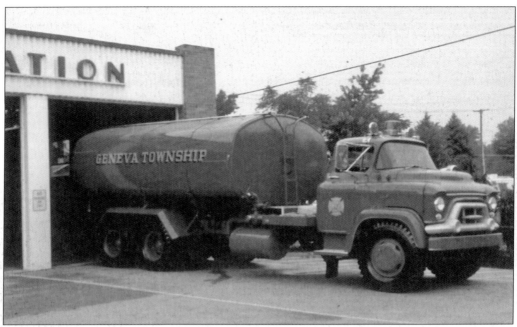

TANKER TRUCK, 1960s. This photograph taken in the 1960s shows a 1957 tanker truck. (Courtesy of the Geneva Fire Department.)

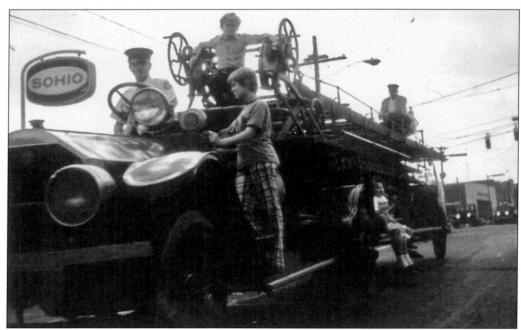

AMERICAN LAFRANCE TILLER TRUCK. This is the 1920s Geneva Fire Department American LaFrance tiller truck pictured in the 1960s. (Courtesy of the Geneva Fire Department.)

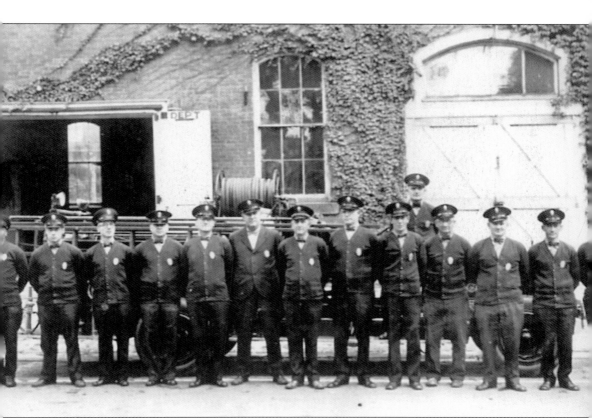

Geneva Fire Department. This photograph was taken prior to 1934 in front of the original fire station on the corner of Park Street and South Broadway. The building has been torn down. Pictured from left to right are G. Palmer, C. Anderson, C. Bromley, H. Eastman, C. Bartlett, B. Sawyer, Chief J. Mason, Capt. J. Cousins, E. Randall, H. Keener (in the back), A. Trumbull, D. C. Craig, E. Jones, and B. Stocking. (Courtesy of the Geneva Fire Department.)

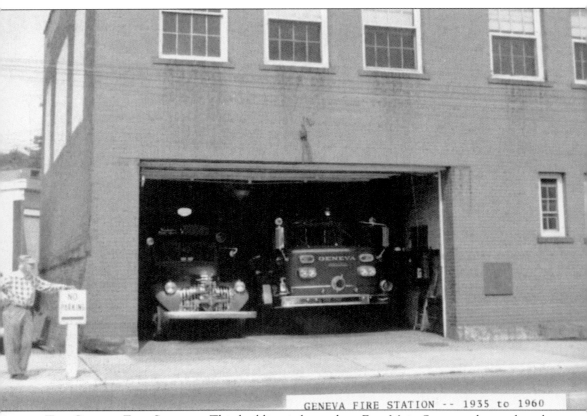

GENEVA FIRE STATION -- 1935 to 1960

THE GENEVA FIRE STATION. This building is located on East Main Street and served as the Geneva fire station from 1935 to 1960. It currently serves as the recreation center. (Courtesy of the Geneva Fire Department.)

THE 1947 GENEVA FIRE DEPARTMENT JEEP. This picture was taken in the early 1960s at the present site of the Geneva Municipal Building. (Courtesy of the Geneva Fire Department.)

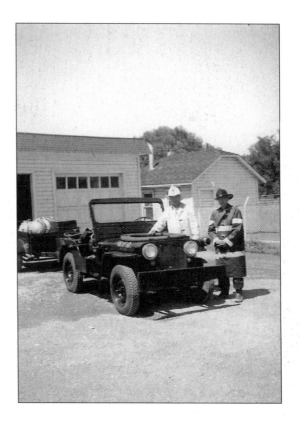

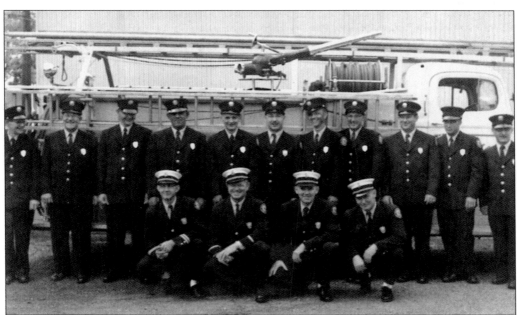

GENEVA FIRE DEPARTMENT, 1950S. These firemen are standing in front of the old white fire truck. (Courtesy of the Geneva Fire Department.)

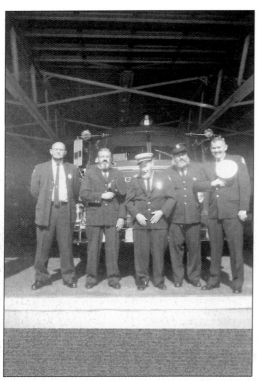

GENEVA FIRE DEPARTMENT, 1966. The year 1966 marked the Geneva centennial. (Courtesy of the Geneva Fire Department.)

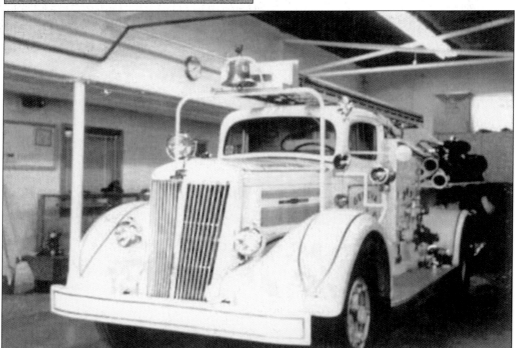

"OLD WHITE." This picture of the 1949 fire truck was taken in the early 1960s. (Courtesy of the Geneva Fire Department.)

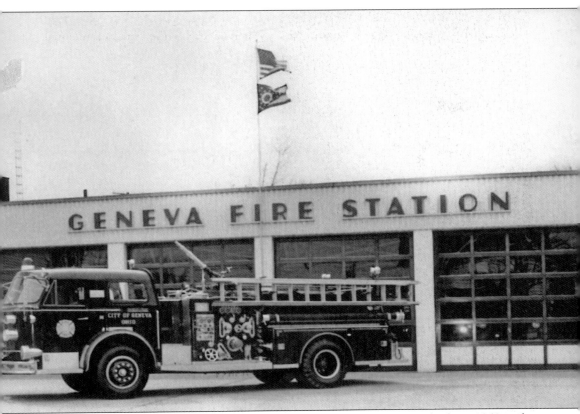

FIRE TRUCK AND CURRENT FIRE STATION. The current fire station was built in 1960 and is located on North Forest Street. (Courtesy of the Geneva Fire Department.)

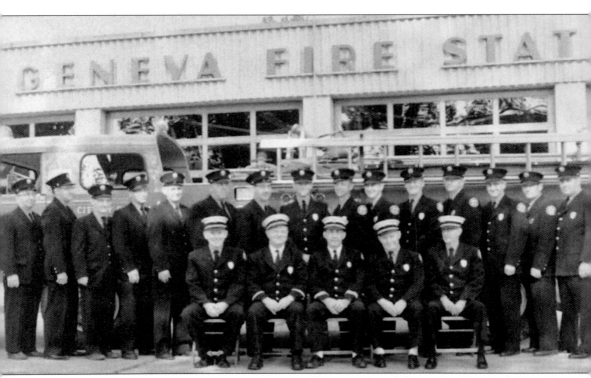

GENEVA FIRE DEPARTMENT, MAY 1962. Pictured here are, from left to right, (first row) Capt. B. Jones, Assistant Chief W. Stauffer, Chief R. Bancroft, Capt. H. McCroden, and Capt. J. Novak; (second row) J. Puckrin, C. Steudler, R. Whaley, F. Shafer, A. Schupska, F. Thor, A. Wolf, R. Kimmy, J. Schack, E. Bernardo, H. Russell, D. Stiffler, Ed Bernardo, H. Pipher, and C. Guthrie. (Courtesy of the Geneva Fire Department.)

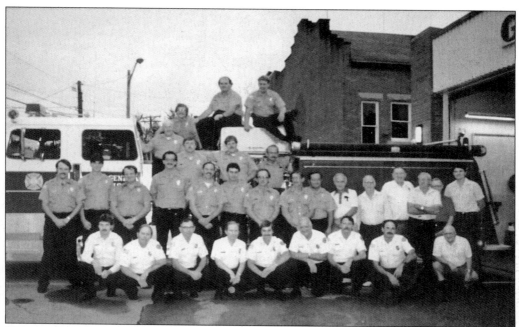

GENEVA FIRE DEPARTMENT, 1985. This photograph was taken at the current fire station on North Forest Street. (Courtesy of the Geneva Fire Department.)

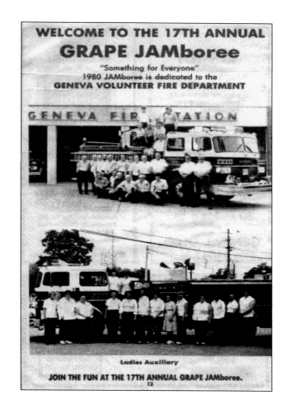

ANNUAL GRAPE JAMBOREE DEDICATION. The 17th annual Grape Jamboree was dedicated to the Geneva Volunteer Fire Department, as seen in this 1980 advertisement. (Courtesy of the Geneva Fire Department.)

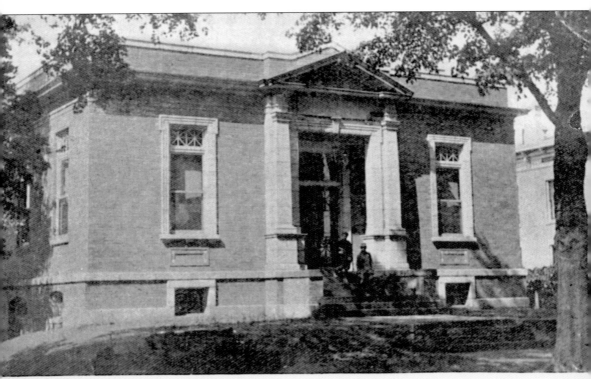

PUBLIC LIBRARY, GENEVA, OHIO.

THE GENEVA PUBLIC LIBRARY, 1910. Andrew Carnegie and the Spencer Memorial Library Association funded the library building and the furnishing of the library at a cost of about $15,000. On June 14, 1910, the building was dedicated. It is located on West Main Street and is now occupied by the Western County Court. (Author's collection.)

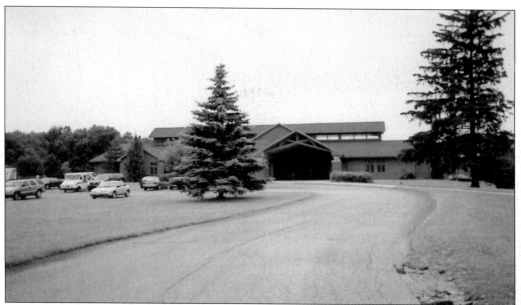

GENEVA PUBLIC LIBRARY. Built in 1997, the current Geneva Public Library is located on Sherman Street. (Author's collection.)

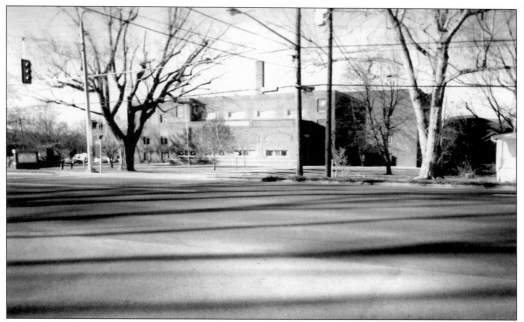

SPENCER ELEMENTARY SCHOOL, 2006. Built in 1924, this school was originally called the East Geneva Rural School, but in 1937, the school changed its name to Spencer Elementary School. Students in kindergarten through the sixth grade attend the school. It is located on North Ridge Road East (U.S. Route 20). (Author's collection.)

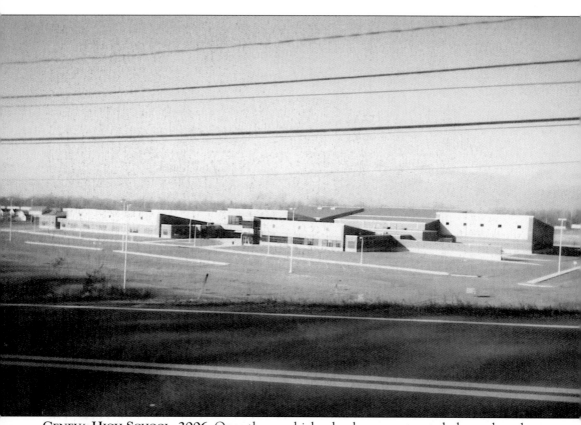

GENEVA HIGH SCHOOL, 2006. Once the new high school was constructed, the students began attending during the second semester of the 2005–2006 school year. Students in grades 9 through 12 attend the school. It is located on South Ridge Road East (State Route 84). (Author's collection.)

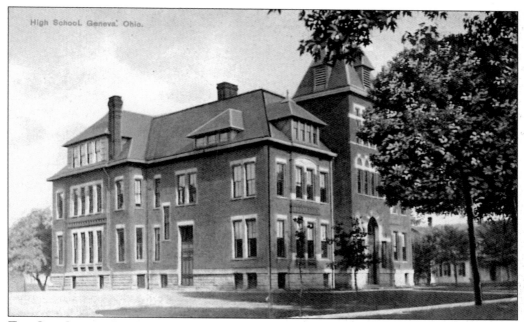

THE OLD GENEVA HIGH SCHOOL. The first class to graduate from this high school was in 1872 and was made up of four graduates. The following year, in 1873, there was only one graduate. (Author's collection.)

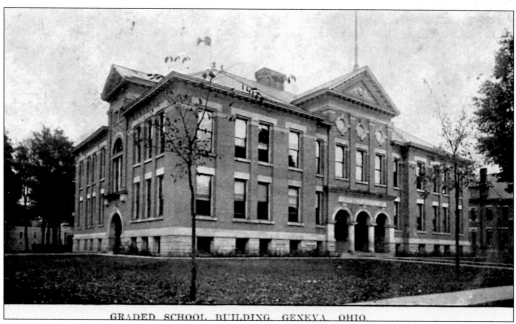

GRADED SCHOOL BUILDING, GENEVA, OHIO.

GRADED SCHOOL BUILDING, 1911. This school building was located on South Eagle Street. (Author's collection.)

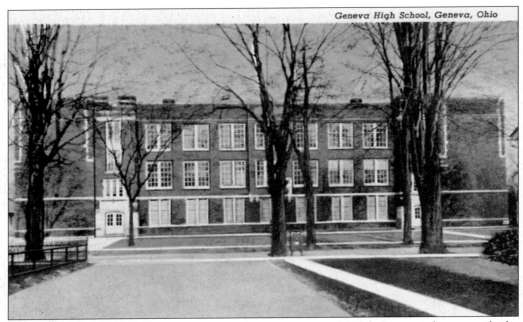

OLD GENEVA HIGH SCHOOL. This building is located on South Eagle Street and is currently the Geneva Elementary School. (Author's collection.)

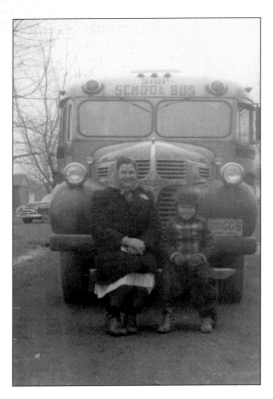

SCHOOL BUS DRIVER. Geneva school bus driver Gertrude Finley sits on the school bus bumper with student Jack Sargent in 1950. (Courtesy of the John D. Sargent Geneva on the Lake collection.)

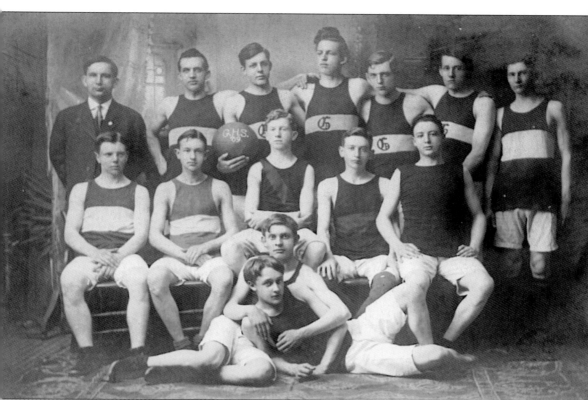

GENEVA HIGH SCHOOL BOYS' BASKETBALL TEAM, 1909. Prof. John D. Marshall made basketball the most successful high school sport. He arrived in Geneva in 1908 and introduced the sport, since no one had ever heard of it. In 1909, the Geneva High School basketball team won the county championship. It also defeated Erie, Oberlin, and East High of Cleveland. The team nearly became champions of the state. (Author's collection.)

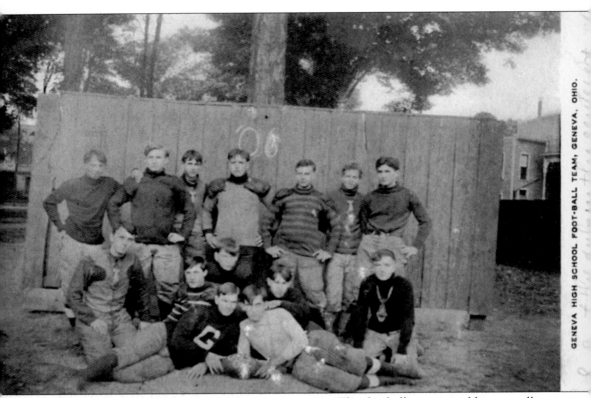

GENEVA HIGH SCHOOL FOOTBALL TEAM, 1906. The football team would eventually get matching uniforms. (Author's collection.)

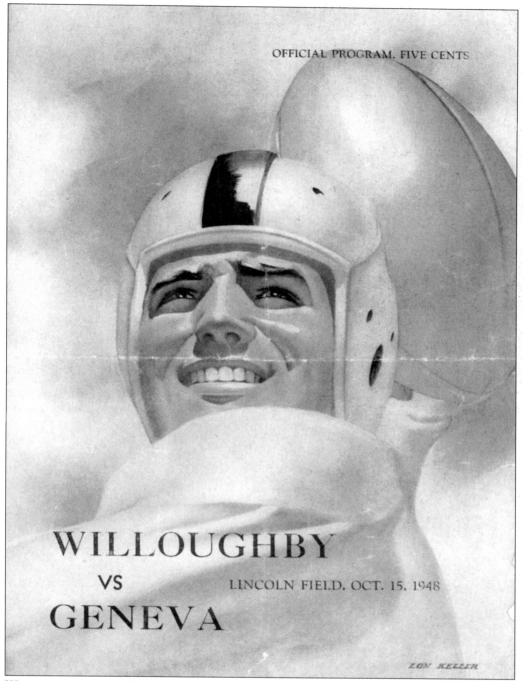

OFFICIAL PROGRAM, FIVE CENTS

WILLOUGHBY
VS
GENEVA

LINCOLN FIELD, OCT. 15, 1948

LON KELLER

WILLOUGHBY VERSUS GENEVA. The October 15, 1948, Willoughby versus Geneva football game was played at Lincoln Field, as noted on this program. (Author's collection.)

PANORAMIC VIEW OF DOWNTOWN GENEVA, APRIL 10, 1926. The automobile boom hit Geneva, and tin lizzies and Ford Model Ts lined the streets. Hitch rails disappeared from downtown, and more cars were parked. Congestion on the city streets increased and so did accidents. The city

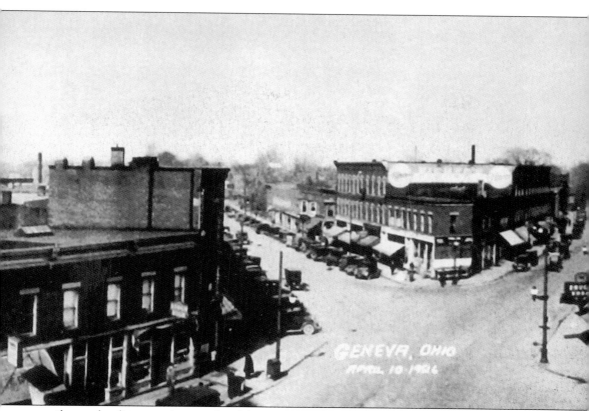

GENEVA, OHIO
APRIL 18 1926

council passed ordinances that regulated downtown parking and eliminated U-turns. (Courtesy of the City of Geneva.)

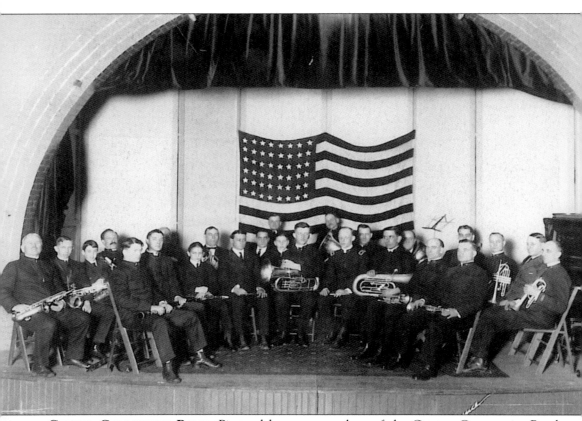

GENEVA COMMUNITY BAND. Pictured here are members of the Geneva Community Band onstage with their instruments. (Courtesy of the City of Geneva.)

GENEVA MUNICIPAL BUILDING. Built in 1988, the Geneva Municipal Building is located on North Forest Street. Administrative offices and the Geneva Police Department, as well as the Geneva city jail, are found here. (Author's collection.)

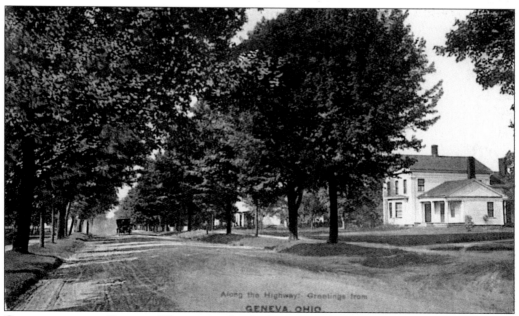

GREETINGS FROM GENEVA. This postcard, which reads, "Along the Highway, Greetings from Geneva, Ohio," is postmarked 1910. (Author's collection.)

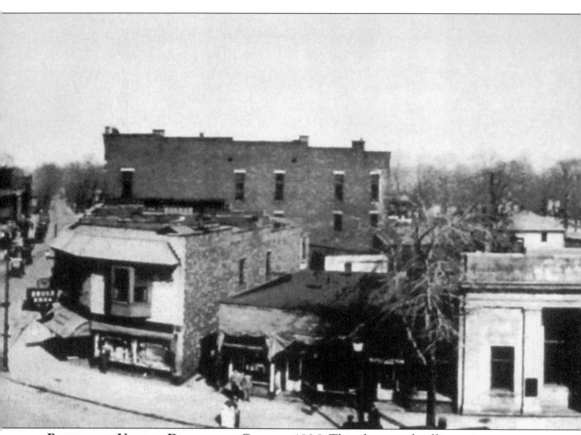

PANORAMIC VIEW OF DOWNTOWN GENEVA, 1926. This photograph offers an interesting view of the east side of South Broadway. East Main Street can be seen on the far left. The Cleveland Painesville and Ashtabula electric line ended, and the property was sold to the C.E.I. Company.

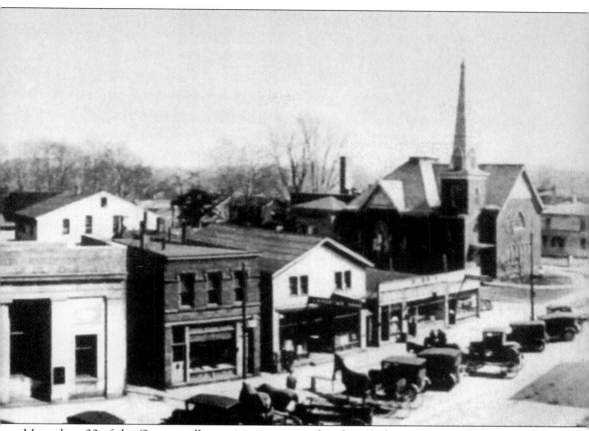

More than 20 of the Geneva village streets were paved with asphalt at this time. (Courtesy of the City of Geneva.)

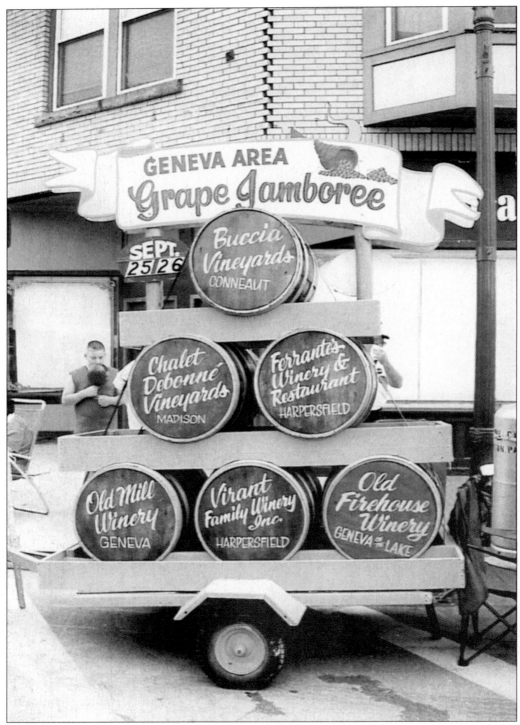

THE GRAPE JAMBOREE BARRELS. Weeks before the annual Grape Jamboree, the barrels are placed at the corner of South Broadway and East Main Street. (Courtesy of Dave Johnson.)

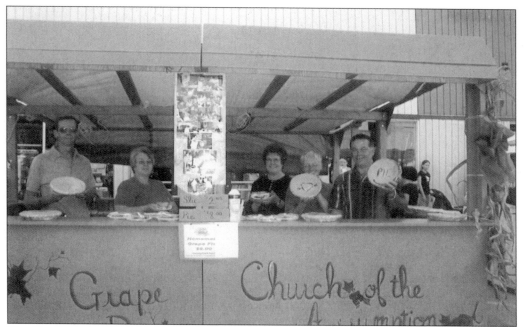

THE PIE BOOTH. The Church of the Assumption hosts a homemade grape pie booth. (Courtesy of Dave Johnson.)

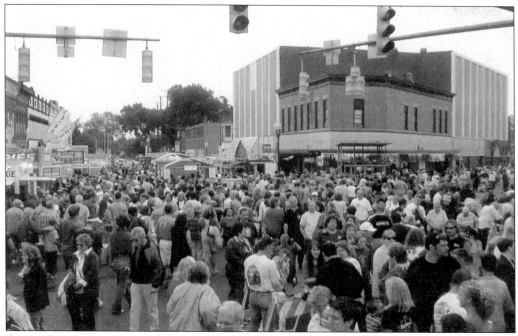

GRAPE JAMBOREE, 2006. Thousands of people come from miles around to celebrate the grape harvesting and to enjoy everything grape. (Courtesy of Dave Johnson.)

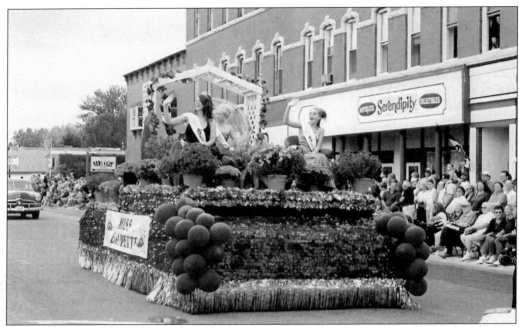

MISS GRAPETTE. The Miss Grapette float is seen here in the 2004 Grape Jamboree parade. Pictured from left to right are Pamela Jessup, second attendant; Krysten Trice, 2004 Miss Grapette (in back); and Chasity Hess, first attendant. (Courtesy of Dave Johnson.)

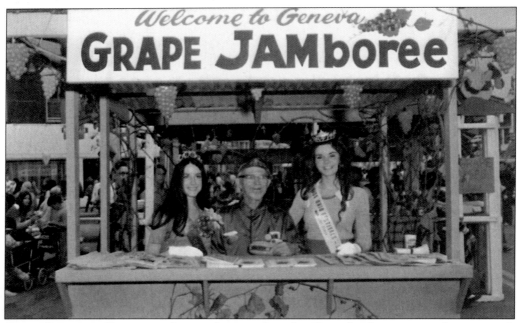

GRAPE JAMBOREE POSTCARD. It is not known when this Grape Jamboree postcard was created. (Author's collection.)

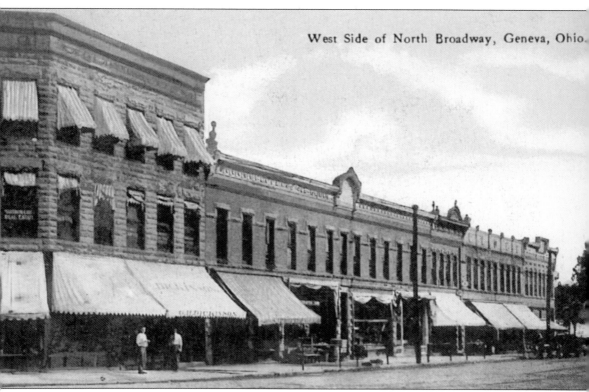

West Side of North Broadway, Geneva, Ohio.

NORTH BROADWAY. The west side of North Broadway is seen here on a postcard postmarked 1914. (Author's collection.)

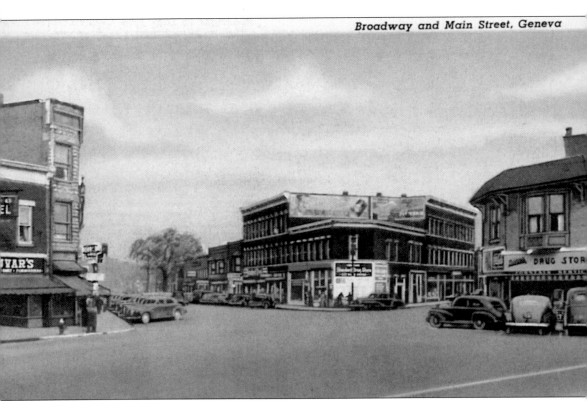

NORTH BROADWAY AND EAST MAIN STREET, AROUND THE 1940S. Geneva has seen its share of drugstores come and go throughout the years. (Author's collection.)

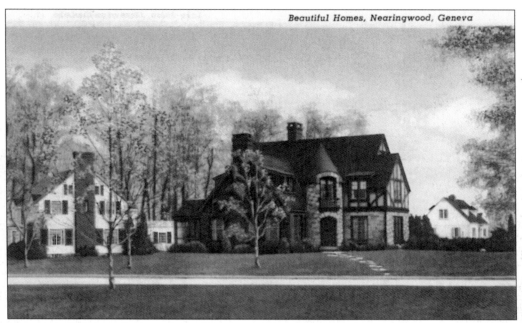

Beautiful Homes, Nearingwood, Geneva

NEARING CIRCLE. A few of the homes on Nearing Circle are seen here in the 1940s. (Author's collection.)

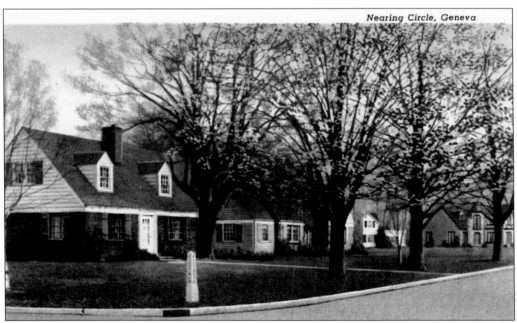

Nearing Circle, Geneva

MORE NEARING CIRCLE HOMES. There are many beautiful homes on Nearing Circle. This photograph was also taken in the 1940s. (Author's collection.)

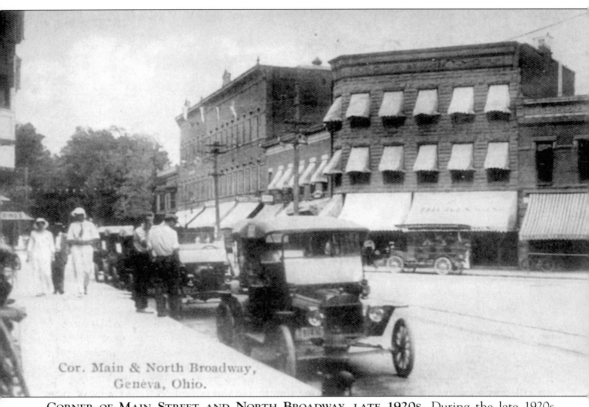

Cor. Main & North Broadway,
Geneva, Ohio.

CORNER OF MAIN STREET AND NORTH BROADWAY, LATE 1920S. During the late 1920s, clothing was casual, and white caps with visors were fashionable. (Courtesy of Edna Turner.)

Two

GENEVA ON THE LAKE

Geneva on the Lake is located on Lake Erie and was Ohio's first summer resort. The first public picnic grounds, named Sturgeon Point, overlooked the lake and was opened in 1869 when Cullen Spencer, a businessman, cleared trees from his lakefront property and created lake access and a park. Spencer named the picnic grounds after the large sturgeon fish that were caught in Lake Erie. He eventually added a boardinghouse and a steam-driven carousel. This was just the beginning of a popular tourist destination.

The tale of Indian Creek is an interesting one. A young Native American named Little John was killed by a falling tree while he was cutting timber. He was buried on the west bank, near the mouth of a creek that flows into Lake Erie. The white men named the creek Indian Creek. A camping resort was later built near the creek.

In the early 1900s, Harvey Firestone, Henry Ford, and John D. Rockefeller visited Geneva on the Lake to do some fishing and camping. By 1910, many cottages and boardinghouses were built, and in 1915, a dance hall was built. By the 1920s, miniature golf, carousel rides, roller-skating, and dancing at the new Pier Dance Hall were popular with vacationers. The village also got city water, which replaced cisterns that collected rainwater. Geneva on the Lake village was incorporated in 1927, and at that time, it had a population of about 120. Several hotels were built by 1930, and a skating rink was constructed. In the 1950s, bingo parlors, nightclubs, and many arcades opened on the main road. Pennsylvania teens were attracted to Geneva on the Lake because of Ohio's lower drinking age in the 1960s. In 1970, the drinking age was raised to 21. By the 1980s, many tourists were returning parents who vacationed there as children. The resort became a nationally known resort.

Several changes have been made to Geneva on the Lake, and some things stayed the same. Old cottages have been torn down and replaced with condominiums, land has been cleared and a lodge built, and Adventure Zone was added. Go-karts, bumper boats, nightclubs, arcades, bed-and-breakfasts, wineries, restaurants, the popular Eddie's Grill, putt-putt golf, and an 18-hole golf course attract many vacationers of all ages each year.

GENEVA ON THE LAKE POSTCARD. Sandy beaches, dance halls, and cottages can be seen here. (Author's collection.)

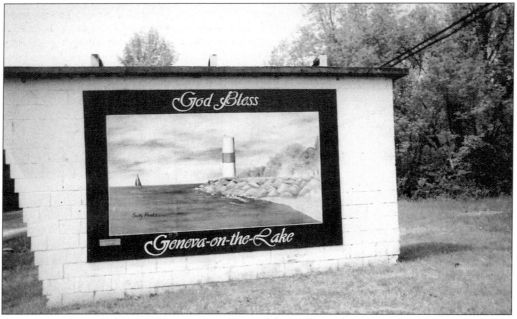

SIGN LOCATED ON STATE ROUTE 534. Painted by Sally Parks in 2003, the block wall was formerly used for the Castaways Nightclub. The nightclub was destroyed by fire in the 1970s. (Author's collection.)

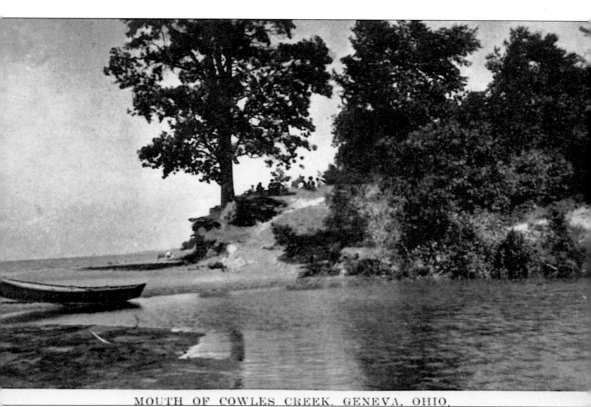

MOUTH OF COWLES CREEK, GENEVA, OHIO.

THE MOUTH OF COWLES CREEK. Named for Noah Cowles, who settled here, Cowles Creek is located at the west end of Geneva on the Lake village. A resort camping area opened in 1882, and it was named Chestnut Grove after the large quantity of chestnut trees. It is now the Geneva State Park. (Author's collection.)

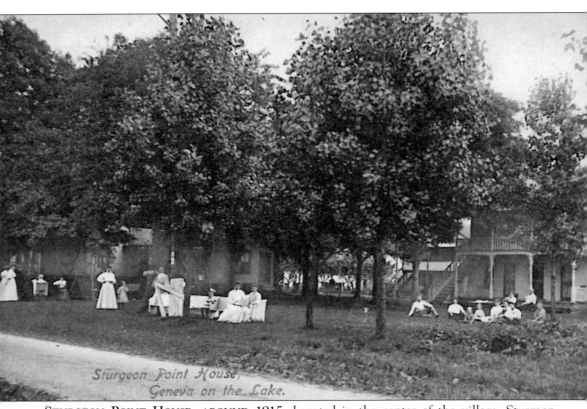

Sturgeon Point House,
Geneva on the Lake.

STURGEON POINT HOUSE, AROUND 1915. Located in the center of the village, Sturgeon Point is now known as Mapleton Beach. Sturgeon Point was named by a man named Harvey Spencer, who was a fisherman who came to the area looking to catch big fish called sturgeons. These fish are also called "fighting monsters" and are known to grow up to 200–300 pounds. (Author's collection.)

SUMMER COTTAGE, AROUND 1908. This was one of the early cottages built at Geneva on the Lake. (Author's collection.)

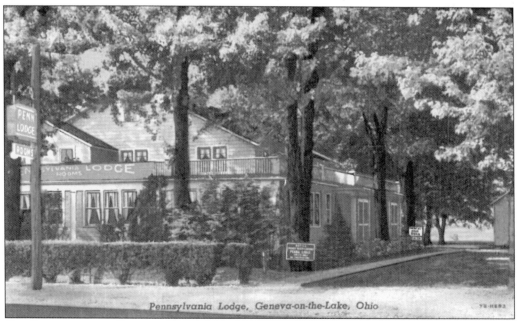

Pennsylvania Lodge, Geneva-on-the-Lake, Ohio

THE PENNSYLVANIA LODGE. The Pennsylvania Lodge was located on the west end of the strip. Although the lodge closed, the building still stands today. It has not changed much and is now occupied by collectible shops. (Author's collection.)

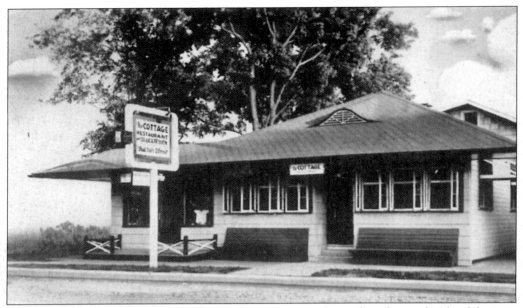

THE COTTAGE RESTAURANT. The Cottage Restaurant was located on the south side of the strip between South Spencer Drive and Golf Avenue. (Courtesy of the John D. Sargent Geneva on the Lake collection.)

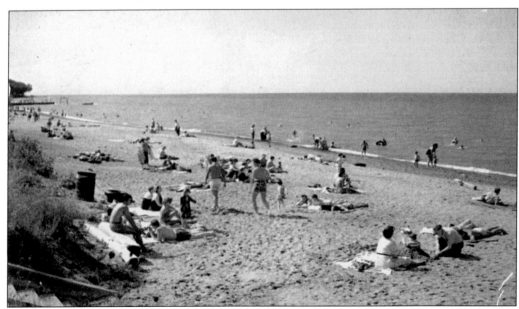

LAKE ERIE BEACH SCENE, 1950S. The beach has always been a haven for vacationers. (Author's collection.)

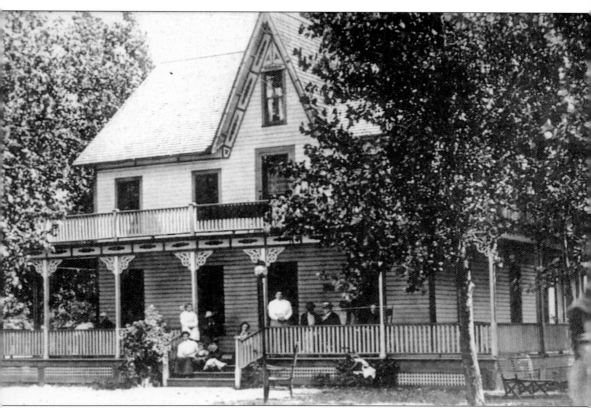

Eagle Cliff Cottage. Built in the 1880s, and also called the Beach Club, Eagle Cliff Cottage is located at the east end of the strip. It has recently been restored and is now a bed-and-breakfast. It is on the National Register of Historic Places. (Courtesy of the John D. Sargent Geneva on the Lake collection.)

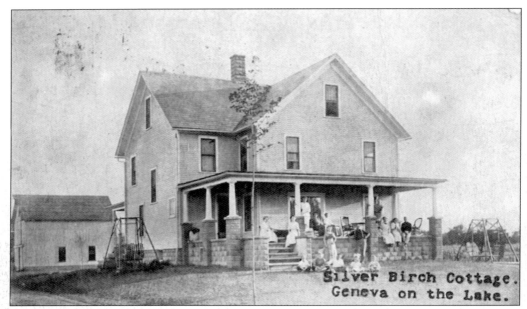

SILVER BIRCH COTTAGE, 1913. Geneva on the Lake has always seen cottages come and go. (Author's collection.)

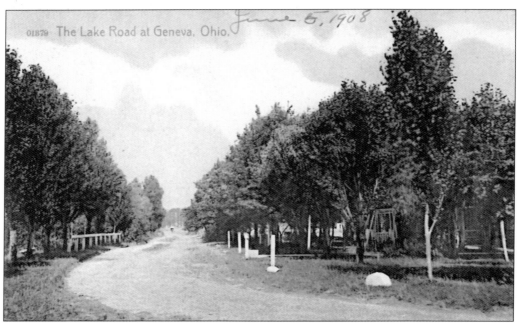

LAKE ROAD IN A POSTCARD VIEW, 1908. This road would eventually get paved and would be a popular road for travel. (Author's collection.)

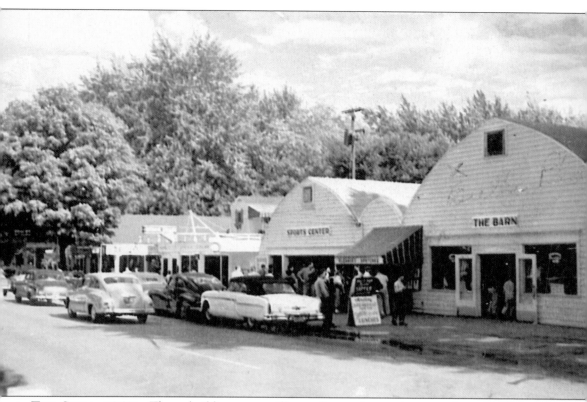

THE STRIP, 1960s. These buildings are still standing today and are easily recognizable. (Author's collection.)

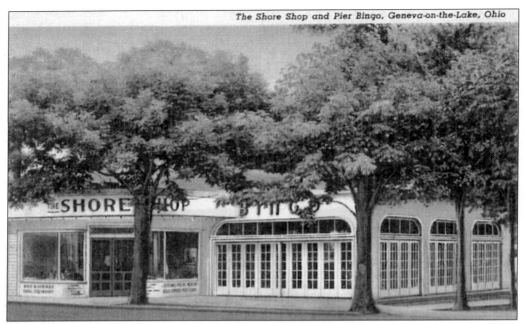

The Shore Shop and Pier Bingo, Geneva-on-the-Lake, Ohio

THE SHORE SHOP AND PIER BINGO. Today this building is occupied by specialty shops. (Author's collection.)

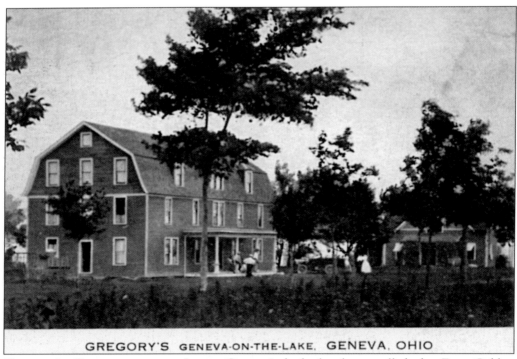

GREGORY'S GENEVA-ON-THE-LAKE, GENEVA, OHIO

GREGORY'S GENEVA ON THE LAKE. Gregory's had also been called the Four Gables. (Author's collection.)

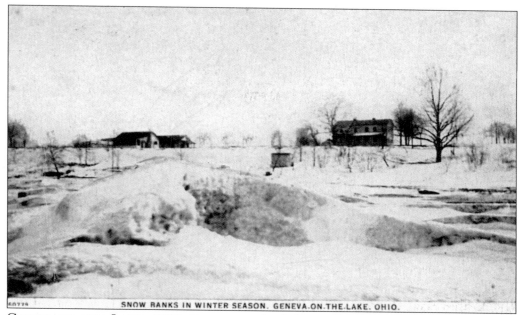

GENEVA ON THE LAKE, 1959. Geneva on the Lake is seen here in the winter of 1959. (Author's collection.)

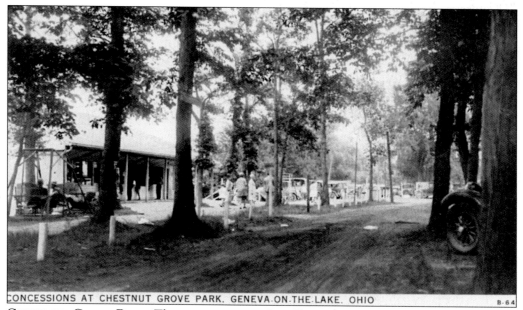

CHESTNUT GROVE PARK. The concession stand at Chestnut Grove Park can be seen in this photograph. (Author's collection.)

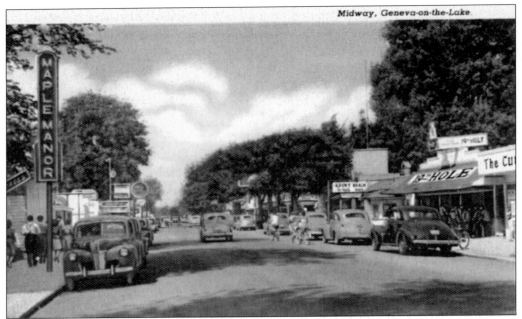

THE STRIP, 1940S. The Geneva on the Lake strip is pictured here around the 1940s. (Author's collection.)

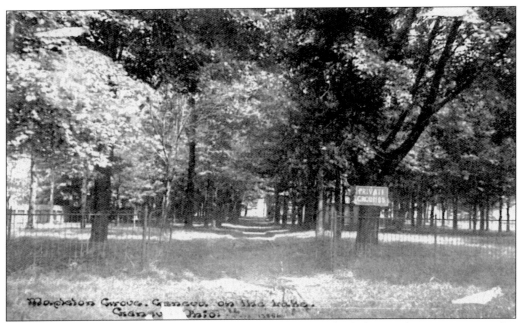

MAPLETON GROVE. Some of the cottages are owner occupied during the summer months. (Author's collection.)

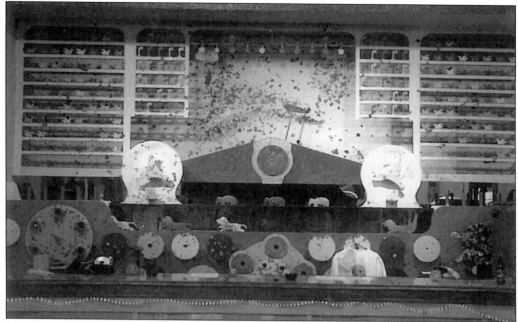

THE SHOOTING GALLERY. This 1928 old-time shooting gallery is located in the Sandy Chanty on the strip. The owner of the restaurant and bar, Pat Bowen, found it by accident when she tore down a wall while remodeling the building. There are only five of these shooting galleries in the world that are still in working order. It originally came from Coney Island. (Courtesy of Pat Bowen.)

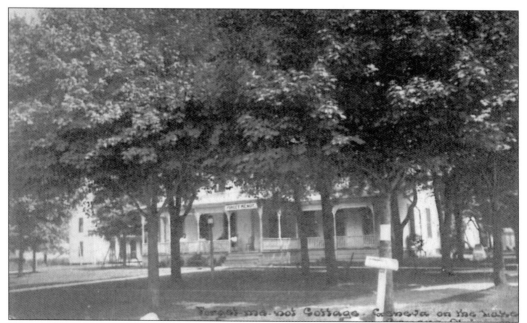

FORGET ME NOT COTTAGE. The Forget Me Not Cottage was a popular place to gather in the early 1900s. (Author's collection.)

THE JENNIE MUNGER GREGORY MEMORIAL MUSEUM. The Jennie Munger Gregory Memorial Museum is located on Lake Road between Grandview Drive and North Putnam Drive. The museum is a farmhouse that was built in the mid-1820s. It has a porch facing the lake, which is to the front of the home. The road was once located north of it, but due to erosion, the road was moved to the south, at its present location. The late Jennie Munger Gregory willed the property to the Ashtabula County Historical Society in the 1960s, and it serves as the society's headquarters. (Author's collection.)

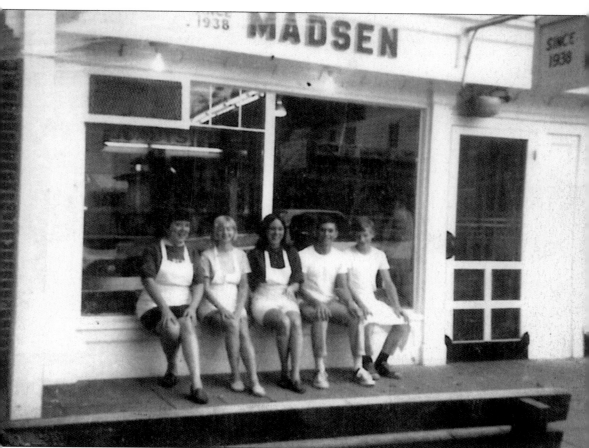

MADSEN DONUTS, 1966. Located on the Geneva on the Lake strip, Madsen Donuts opened in 1938 and is still in business today. Pictured from left to right are Patty Sherwood, Maureen Grady, unidentified, Charlie Tarentina, and Mark Brunner. (Courtesy of the John D. Sargent Geneva on the Lake collection.)

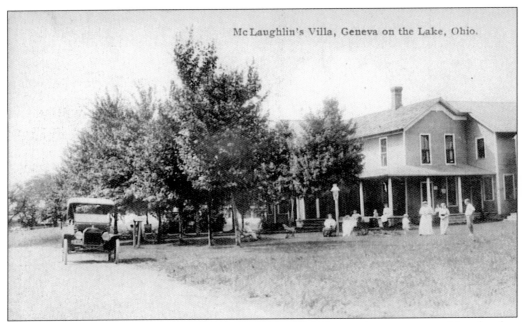

McLaughlin's Villa, Postcard View. Cottages of different sizes were rented by the day, week, month, or season. (Author's collection.)

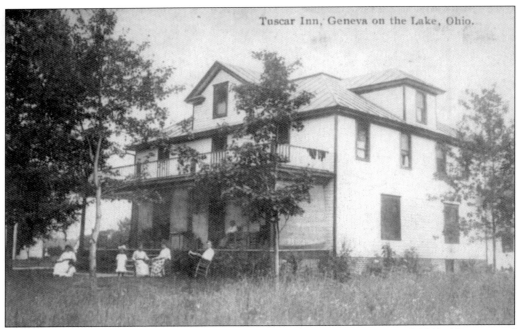

The Tuscar Inn. A group of people relax in front of the Tuscar Inn around 1910. (Courtesy of the John D. Sargent Geneva on the Lake collection.)

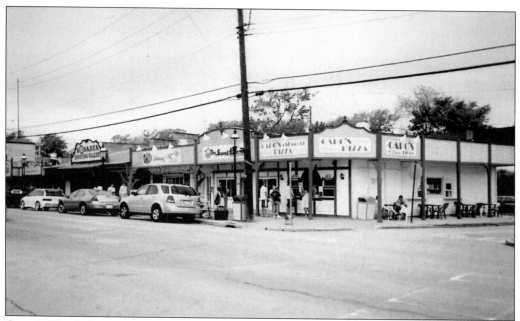

CAPO'S OLD WORLD PIZZA. Located on the strip, Capo's opened in 1965 and is still in business today. In 1977, Capo's opened a second location on West Main Street in Geneva city. To the left of Capo's, the Sand Bar, the Sandy Chanty, and the Bonanza Shooting Gallery can be seen. (Author's collection.)

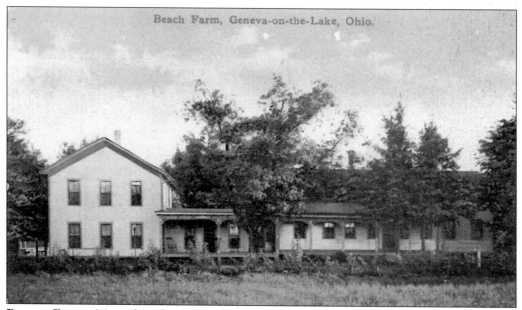

BEACH FARM. Many boardinghouses and hotels were noted for their family-style good home-cooked meals. (Author's collection.)

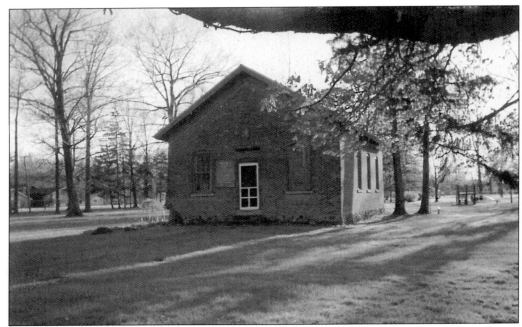

THE SCHOOLHOUSE. This one-room schoolhouse was built in 1838 and was located in the present Geneva Township Park at the east end on the strip on Lake Road. The wooden structure was replaced by a brick structure in 1883 using the same foundation. The school was last used during the 1908–1909 school year. (Author's collection.)

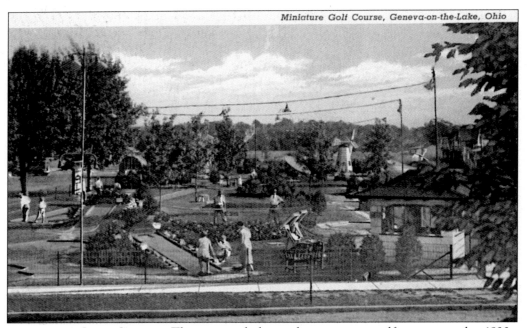

Miniature Golf Course, Geneva-on-the-Lake, Ohio

MINIATURE GOLF COURSE. This postcard shows the miniature golf course in the 1930s. (Courtesy of Georgette Allison.)

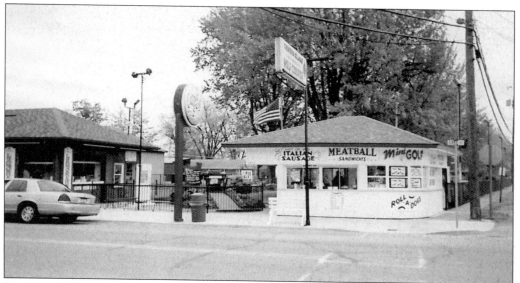

MINIATURE GOLF COURSE, 2007. Established in 1924, this miniature golf course is the oldest in the United States that is in continuous play. (Author's collection.)

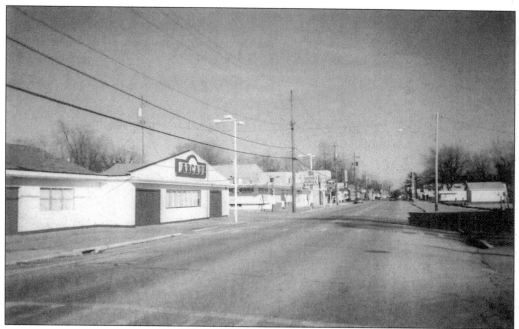

THE STRIP, NOVEMBER 2006. Although the businesses are closed for the winter season, Geneva on the Lake is a popular vacation spot during the summer months. (Author's collection.)

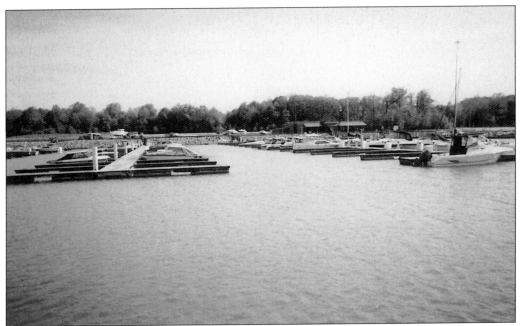

THE GENEVA MARINA. Located to the west of the strip, the marina is located in the Geneva State Park. It was built in the 1990s and has six public boat ramps, a small boat harbor, and a 385-slip marina. (Author's collection.)

CITY OF GENEVA FIRE DEPARTMENT AMERICAN LAFRANCE FIRE TRUCK, 1960. This picture was taken in the parking lot of the Geneva Marina. In the background, the bathhouse can be seen. It has since been torn down. (Courtesy of the Geneva Fire Department.)

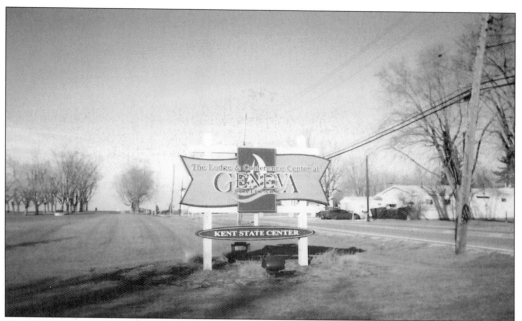

THE LODGE AND CONFERENCE CENTER AT GENEVA STATE PARK, 2006. The lodge opened in 2004 and is located on over 20 acres along the Lake Erie coastline. It had a total cost of over $16.7 million. A few of its amenities include 109 rooms, an upscale restaurant, a lounge, a game room, an indoor pool and hot tub, and a gift shop. Kent State University added a training facility to the lodge. The training facility increases the employees' skill levels by offering noncredit programs on computers, customer service, marketing, quality assurance, and management. It is located on North Broadway (State Route 534), Geneva on the Lake. (Author's collection.)

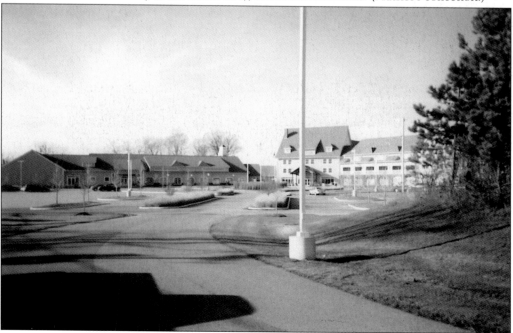

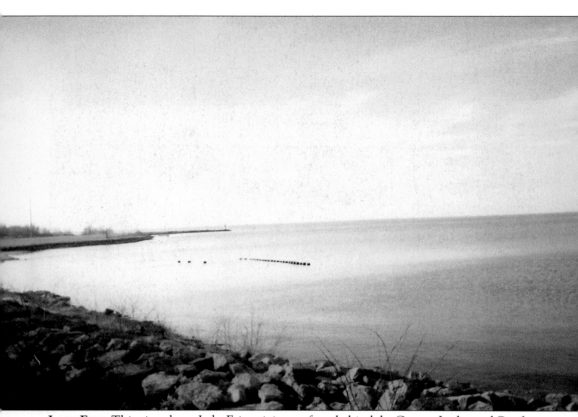

LAKE ERIE. This view shows Lake Erie as it is seen from behind the Geneva Lodge and Conference Center. Lake Erie is the fourth largest and shallowest of all of the Great Lakes. The Erie Canal was completed around 1820, and shipping on Lake Erie increased, as did the population along the lake. (Author's collection.)

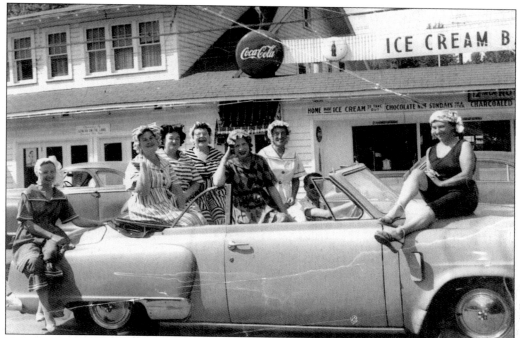

THE FLAPPER ERA. These women are enjoying themselves as they re-create the flapper era. In the background, the ice-cream bar and the bingo parlor can be seen. The building still stands today and is located on the corner of New Street and Lake Road on the strip. (Courtesy of the John D. Sargent Geneva on the Lake collection.)

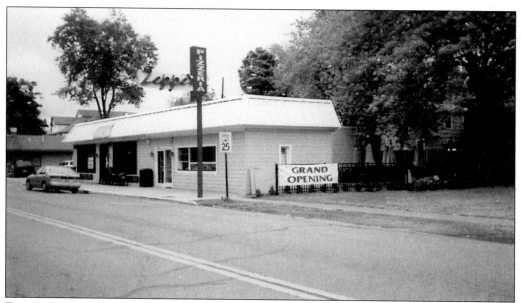

ZEPPE'S PIZZA, 2007. Zeppe's teamed up with Gale's Coffee Corner on the Lake and remodeled a building with adjacent storefronts. With a shared outdoor patio, the pizza shop and coffeehouse are a great combination. They are located on the west end of the strip. (Author's collection.)

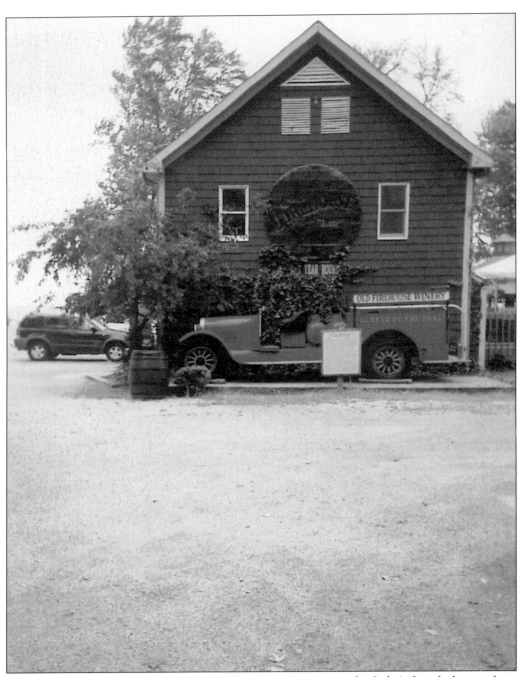

THE OLD FIREHOUSE WINERY. This building was Geneva on the Lake's first firehouse, from 1924 to 1932. The Geneva on the Lake volunteer fire department was organized in 1924. There were seven members, with Emery Tyler as chief. The other six members were Clarence Hoskins, Eusebio "Pop" Pera, Charles Craine, Arthur Bowers, Sidney Ramsey, and Charles Warner. The fire truck "Old Betsy" was named by the firemen for its many years of dependable service. It is a Dodge fire truck that was made by Grahm Brothers. (Author's collection.)

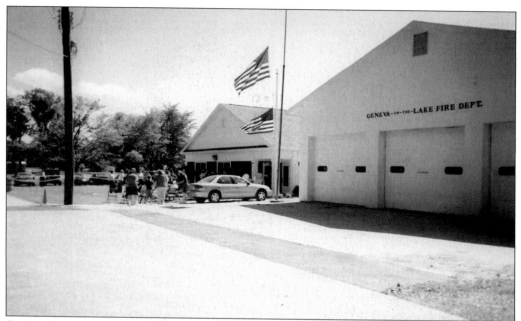

SAFETY SERVICES CENTER VILLAGE HALL FACILITY. Located at 4929 South Warner Drive, this building was completed in 2007. The picture shows a gathering for the ribbon-cutting ceremony on June 20, 2007. The building was constructed adjacent to the village fire hall, which was built in 1970. (Author's collection.)

THE OLD VILLAGE HALL. This building now sits vacant at 4964 South Spencer Drive. (Author's collection.)

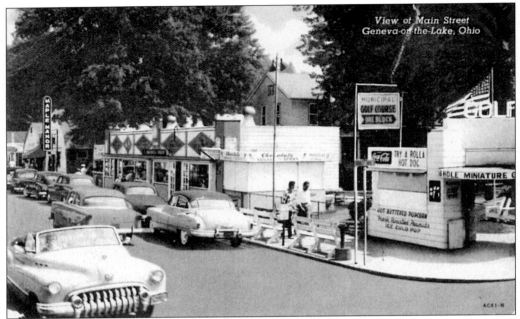

THE STRIP, AROUND THE 1950S. The strip is lined with Oldsmobiles, Packards, and Fords of blue-collar folks who came to the resort to go to the beaches, bingo parlors, and dance halls. (Author's collection.)

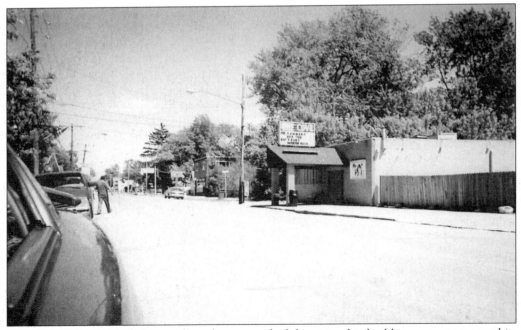

THE COVE NIGHTCLUB. Located on the east end of the strip, this building was constructed in the early 1960s. Joe Pesci and his band (before he became an actor) and Jimi Hendrix played here. It is still in business today. (Author's collection.)

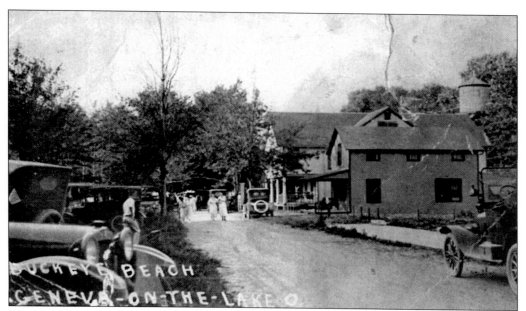

BUCKEYE BEACH, AROUND 1920. The road seen here has been paved and is now known as New Street. (Author's collection.)

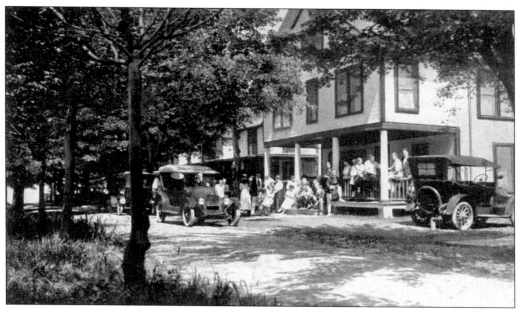

THE BUCKEYE COTTAGE. Built around 1917, the Buckeye Cottage still stands today and is located on New Street. (Author's collection.)

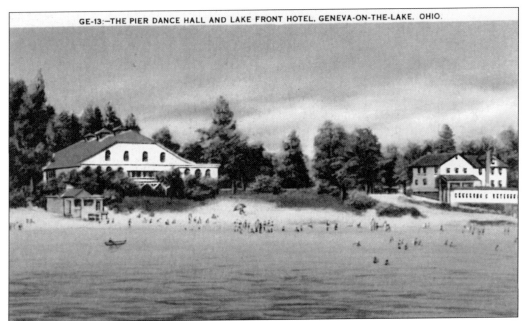

THE OLD PIER DANCE HALL. Built in 1928, the ballroom was expanded before World War II. It was the biggest ballroom between Sandusky, Ohio, and Buffalo, New York. Several popular entertainers played at the pier, such as Ozzie and Harriet Nelson, Jimmy Dorsey, Lawrence Welk, and Cab Calloway. It was located north of the current Time Square. It closed in the 1960s and was torn down in 1995. The building on the right is the Lake Front Hotel. (Author's collection.)

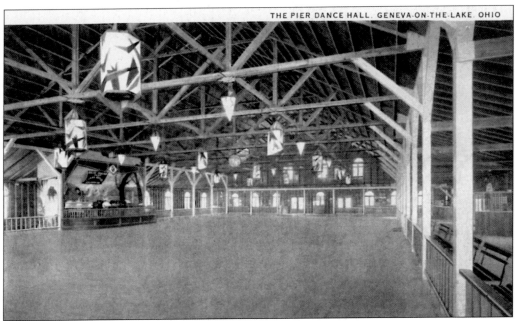

THE PIER DANCE HALL. The interior of the Pier Dance Hall is seen here. (Author's collection.)

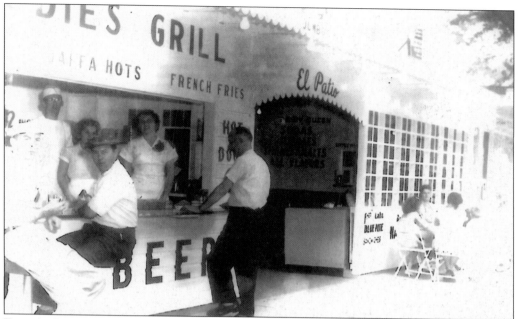

EDDIE'S GRILL, 1954. Eddie's Grill opened in 1950 and still maintains the 1950s atmosphere today with the jukeboxes, root beer barrel, and neon signs. Eddie Sezon has made several additions over the years. Dairy Queen was added in 1952, a pizza parlor in 1980, an arcade in 1983, a 250-car parking lot across the street in 1993, and a back outdoor patio in 2002. (Courtesy of Eddie Sezon.)

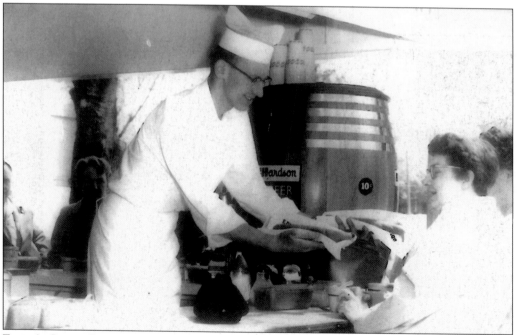

EDDIE'S GRILL. Sezon, owner of Eddie's Grill, is serving foot-long hot dogs and Richardson Root Beer in 1953. (Courtesy of Eddie Sezon.)

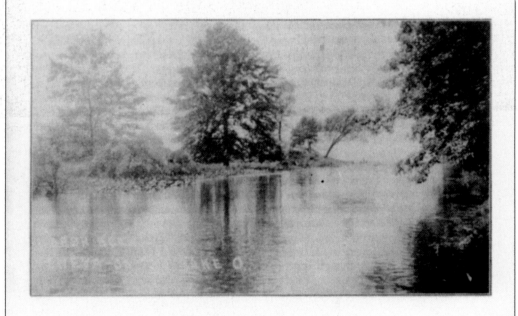

August 1982
EARLY HISTORY OF GENEVA-on-the-Lake
Ashtabula County, Ohio

Early scene of Cowles Creek
The marsh on the west of the village, now the Geneva State Park, has Cowles Creek streaming through it, so named for Noah Cowles who settled on its banks. Prior to the opening of the state park the area was known as Chestnut Grove, a popular resort camping area that originated in 1882. It was so named because of the abundance of chestnut trees.

ASHTABULA COUNTY HISTORICAL SOCIETY BROCHURE. This August 1982 brochure celebrates the early history of Geneva on the Lake. (Courtesy of Georgette Allison.)

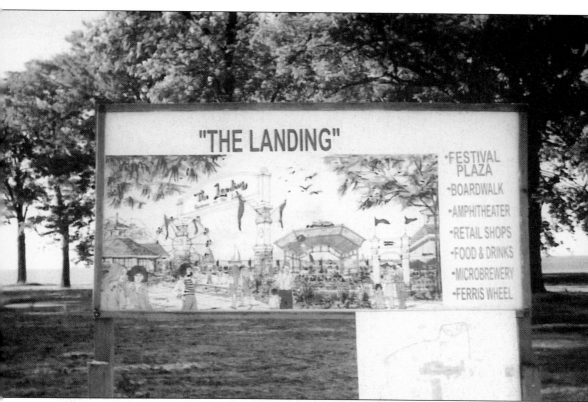

The Landing. This 2007 sign shows the development the Landing. Geneva on the Lake will see some drastic changes in the coming years. (Author's collection.)

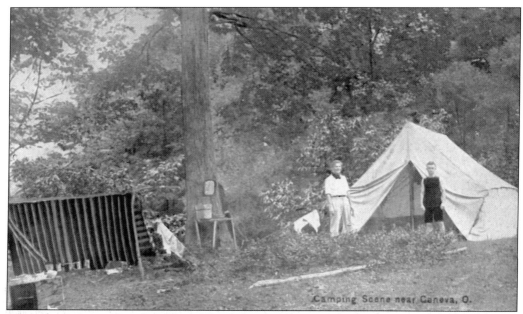

CAMPING SCENE, 1910. Geneva on the Lake has always been and continues to be an admired location for camping. (Author's collection.)

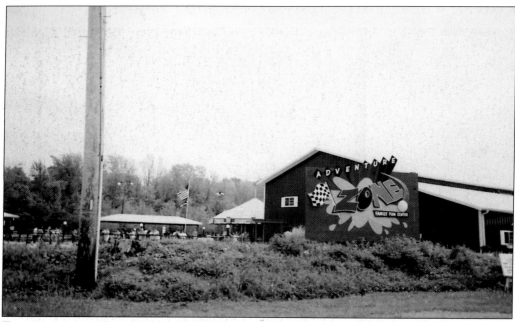

THE ADVENTURE ZONE FAMILY FUN CENTER. Adventure Zone originally opened in 1997 and is located on the west end of the strip. It has a 1957 Allan Herschell merry-go-round, go-karts, bumper boats, miniature golf, batting cages, and a huge arcade. (Author's collection.)

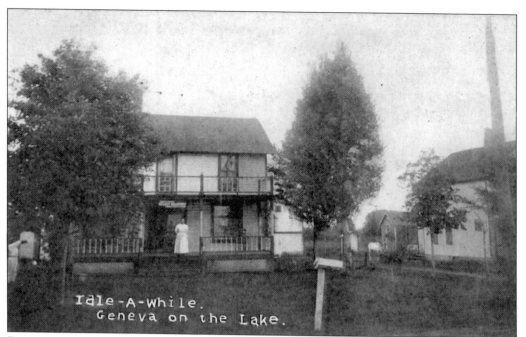

Idle-A-While.
Geneva on the Lake.

RAMSEY'S IDLE-A-WHILE. Beginning in the 1920s, the Idle-A-While was a popular resort. Located along the Lake Erie shores, the resort had a private beach, tennis courts, a dining room, and spacious grounds. It was known for cleanliness, comfort, and hospitality. It later closed and was torn down. It was located on the property where the Sturgeon Point Condominiums are now located. (Courtesy of the John D. Sargent Geneva on the Lake collection.)

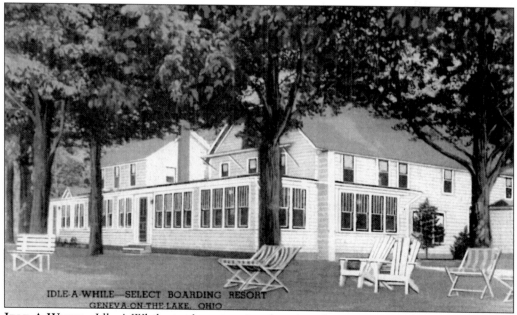

IDLE-A-WHILE—SELECT BOARDING RESORT
GENEVA ON THE LAKE, OHIO

IDLE-A-WHILE. Idle-A-While is shown as a select boarding resort in this postcard view. (Author's collection.)

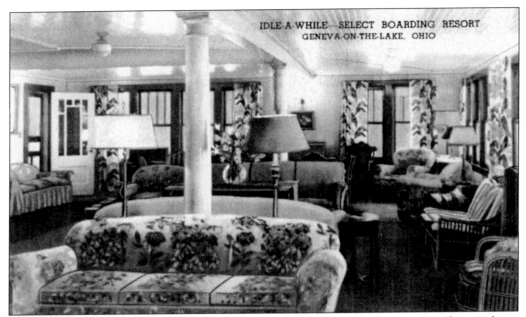

THE IDLE-A-WHILE INTERIOR IN A POSTCARD VIEW. The lobby of the resort can be seen here. (Author's collection.)

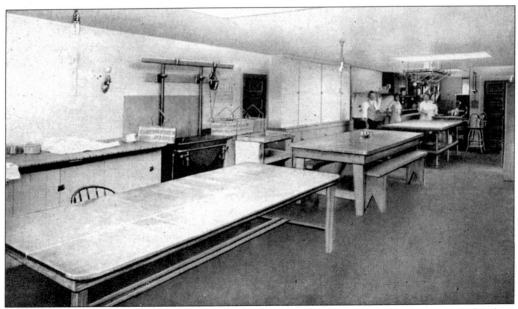

THE KITCHEN OF THE IDLE-A-WHILE IN A POSTCARD VIEW. The resort had a spacious kitchen and dining room used to serve the guests. (Author's collection.)

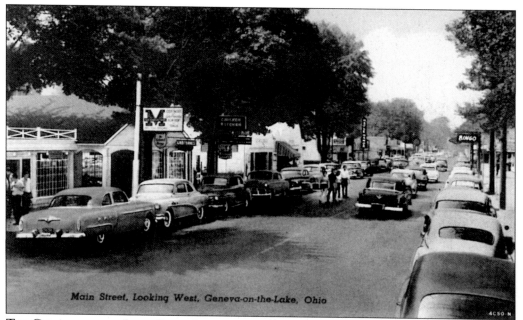

Main Street, Looking West, Geneva-on-the-Lake, Ohio

THE GENEVA ON THE LAKE STRIP, LOOKING WEST. During the 1950s, nightclubs, game arcades, and bingo parlors opened on Main Street, now known as the strip. (Author's collection.)

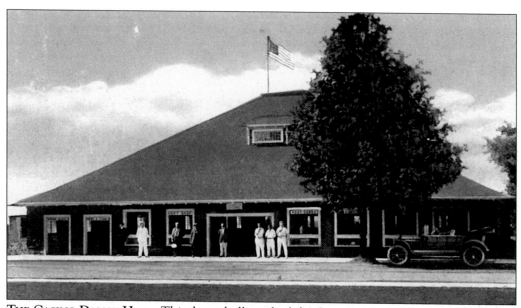

THE CASINO DANCE HALL. This dance hall was built by George Glick, Maurice Johnston, and Bert and Jenny Gregory in the spring of 1915. A couple of years later, Johnston and Glick bought out the Gregorys' interest and operated the dance hall themselves. In 1937, the Casino Dance Hall was sold to Mr. and Mrs. E. Pera. It later closed. (Author's collection.)

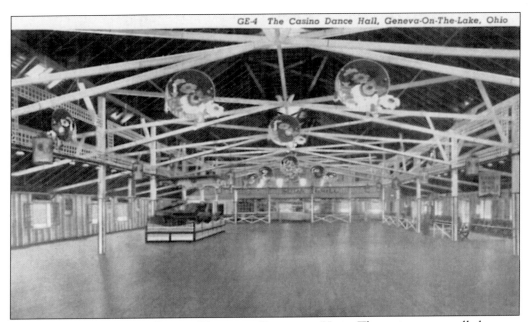

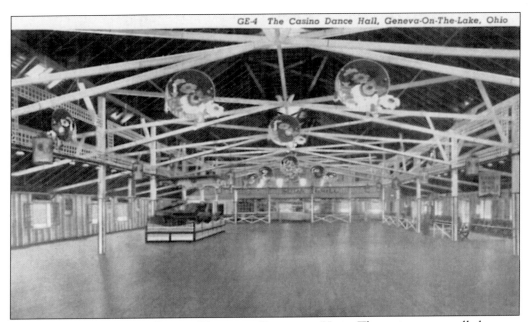

INTERIOR OF THE CASINO DANCE HALL IN A POSTCARD VIEW. The casino eventually became a roller rink. (Author's collection.)

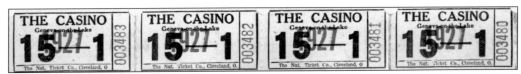

THE CASINO DANCE HALL 1927 TICKETS. The casino was rated among the best in this part of the country. (Author's collection.)

Three

HARPERSFIELD

Col. Alexander Harper served in the American Revolution and returned to Harpersfield, New York, where he lived. In 1797, he and his associates set out to find a piece of property that would suit him and his family. Harper found one that he liked in the Western Reserve and named it Harpersfield Township, which he named after "old" Harpersfield, New York. He then returned to New York to give his family the news. In March of the following year, he and his family, along with Ezra Gregory, William McFarland, and their families, left their homes in New York for Harpersfield, Ohio. There were a total of 25 emigrants on the journey. They arrived in June 1798 and erected a shack made from bark located about one-half of a mile from the present Shandy Hall, where they all stayed until more shacks were built.

Ashtabula County was organized on January 22, 1811. Harpersfield Township included the land within its limits along with Hartsgrove, Trumbull, and Geneva Township. Geneva Township was detached on May 22, 1816, to form its own separate township. In 1825, Trumbull was detached from Harpersfield and divided into the present Hartsgrove and Trumbull Townships.

Harpersfield has always been known as a farming community. The residents enjoy its reputation of being known now for its wineries and the grape-growing industry.

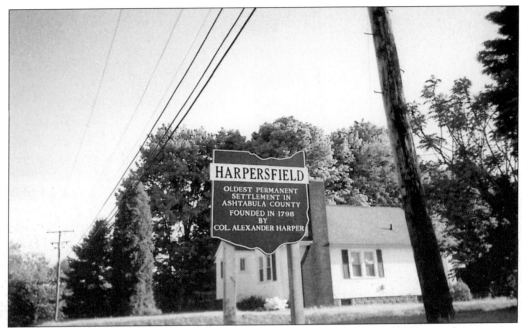

HARPERSFIELD SIGN. This sign is located on State Route 534. (Author's collection.)

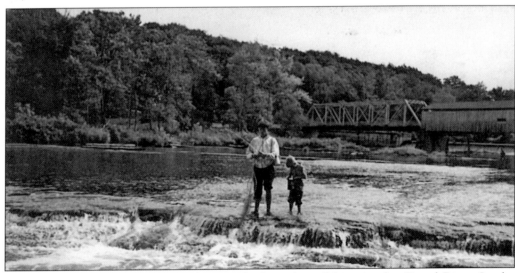

THE GRAND RIVER. This 1970s photograph shows boys fishing in the Grand River. In the background, note the covered bridge before the walkway was added, the steel bridge, and the dam. (Author's collection.)

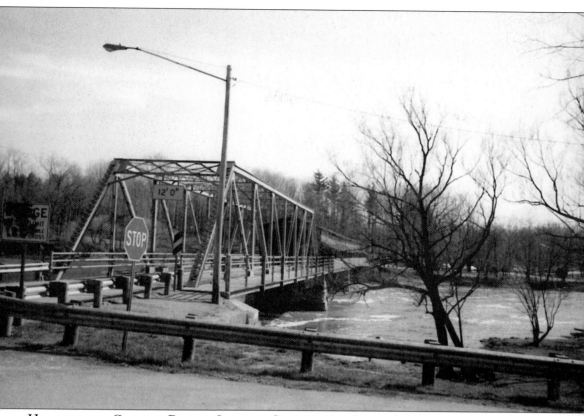

HARPERSFIELD COVERED BRIDGE, LOOKING SOUTH, 1996. Located on Harpersfield Road, the covered bridge was built in 1868. A 140-foot steel extension was added in 1913, and a walkway was added in 1992. (Author's collection.)

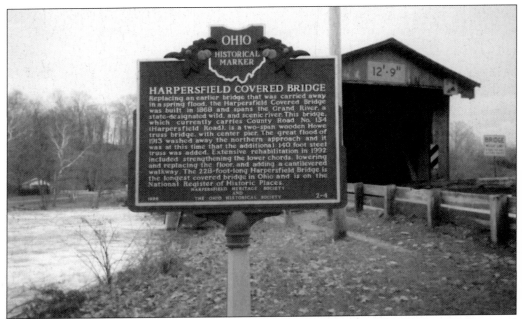

HARPERSFIELD COVERED BRIDGE, OHIO HISTORICAL MARKER. The Harpersfield covered bridge is listed on the National Register of Historic Places, which is authorized under the National Historic Preservation Act of 1966. It is managed by the National Park Service. This marker is located on the south end of the bridge. (Author's collection.)

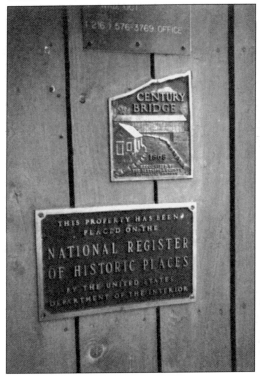

PLAQUES ON THE HARPERSFIELD COVERED BRIDGE. In addition to being on the National Register of Historic Places, the bridge is also recognized by the Ashtabula County Historical Society as a century bridge. (Author's collection.)

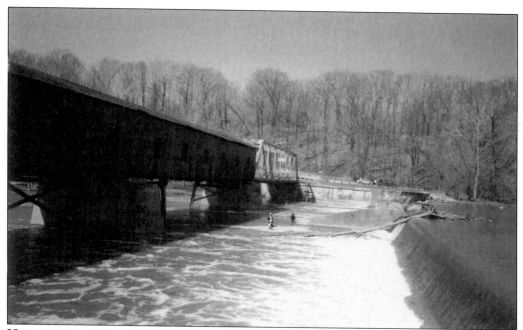

HARPERSFIELD DAM, 1996. The Harpersfield dam is located on the east side of the bridge. The Grand River runs over the dam and is a popular fishing spot. The river is 98 miles long and runs through Ashtabula, Lake, Geauga, and Trumbull Counties. (Author's collection.)

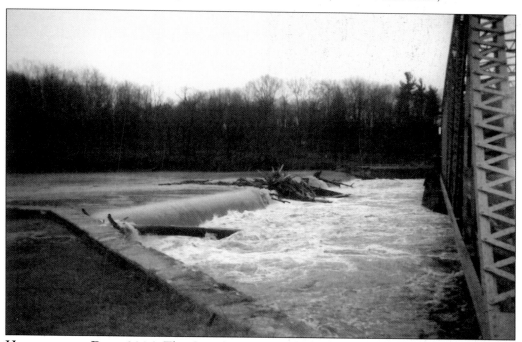

HARPERSFIELD DAM, 2006. The Grand River was high after much rainfall, and many homes in the area got damaged during the flood. The river reached approximately 11 feet above flood level. Several trees washed over the dam. (Author's collection.)

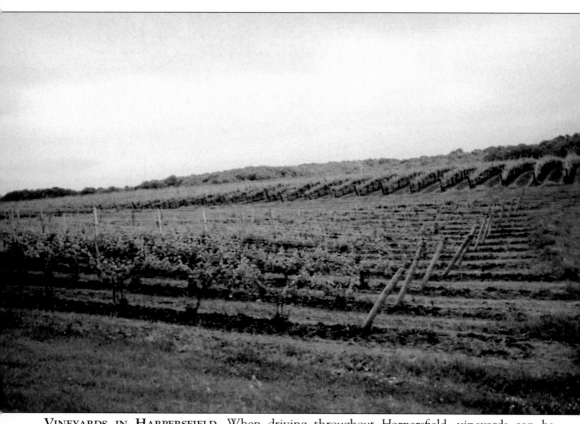

VINEYARDS IN HARPERSFIELD. When driving throughout Harpersfield, vineyards can be seen for miles. These vineyards supply the local wineries with grapes to make their wines. (Author's collection.)

Four

REES' DRUG STORE

On November 3, 1938, Hoffner's Drug Store was purchased by Thomas "Doc" Rees and his wife, Reva. They changed the name to Rees' Cut Rate Drug Store. Reva assisted her husband, Doc, with the store for many years. Rees' Drug Store was a main focal point of Geneva, a popular place to gossip, a drugstore, and much more. It offered hot dogs, ice cream, sundaes, floats, and soda fountain drinks. After 63 years of business, and three generations of pharmacists, Rees' closed its doors in 2001. On December 1, 2006, David Gale and Andrew White reopened Rees' Drug Store. They renamed it Arthur and Lloyd's General Store to honor their grandfathers. The pharmacy is now gone, but in its place is a pharmacy museum that Gale and White established as a tribute to the Rees family. Arthur and Lloyd's offers soda fountain drinks from the original soda fountain. It also offers a menu of treats like Rees' did in the past. It has a collection of merchandise, including chocolates, collectibles, unique gift items, and the Arthur and Lloyd's exclusive private collection.

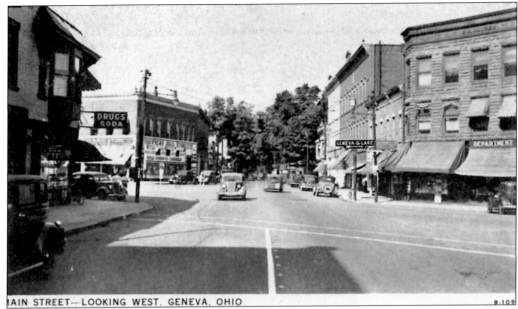

MAIN STREET—LOOKING WEST, GENEVA, OHIO B-109

EAST MAIN STREET, LOOKING WEST. Hoffner's Drug Store can be seen on the far left. (Courtesy of Edna Turner.)

REVA AND DOC REES, 1958. After Reva and Doc Rees purchased Hoffner's Drug Store, it would see three generations of the Rees family as owners. (Courtesy of the Rees family collection.)

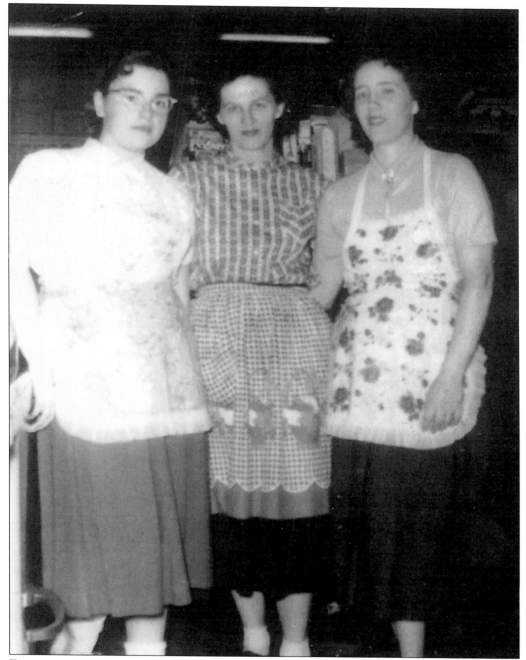

EMPLOYEES OF REES' DRUG STORE, 1958. Pictured from left to right are Donna Pulsipher, Myrna Wetzel, and Florine Bradburn. These employees kept busy waiting on customers behind the food counter. The employees really enjoyed working for the Rees family. (Courtesy of the Rees family collection.)

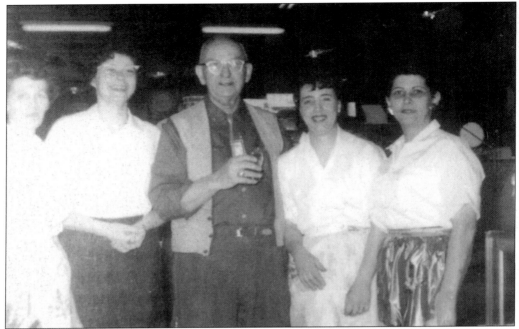

DOC REES AND HIS EMPLOYEES, JANUARY 1960. Pictured from left to right are Myrna Wetzel, Barb Karaffa, Doc Rees, Florine Bradburn, and Ester Karaffa. (Courtesy of the Rees family collection.)

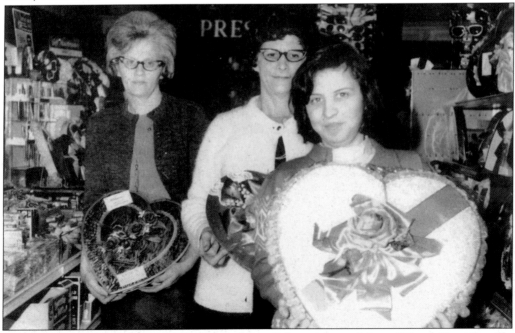

REES' EMPLOYEES, FEBRUARY 1959. Pictured from left to right are Myrna Wetzel, Ester Karaffa, and Sheila Fowler. Each year, a contest was held among the Rees' employees to see who could sell the most Valentine's Day candy. (Courtesy of the Rees family collection.)

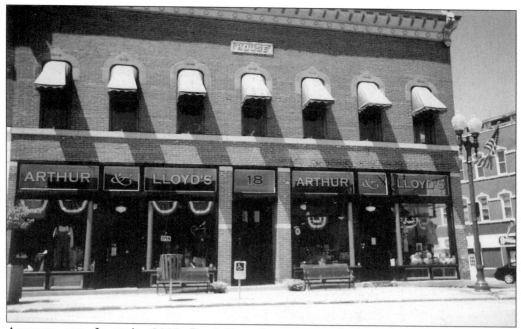

ARTHUR AND LLOYD'S, 2007. Rees' Drug Store eventually became Arthur and Lloyd's. (Author's collection.)

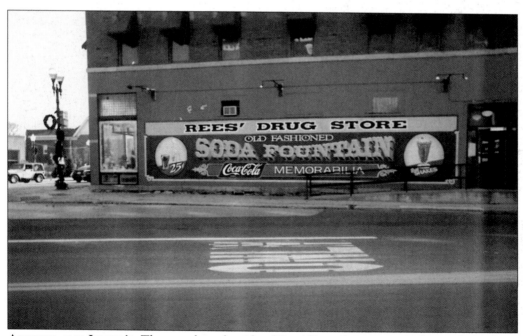

ARTHUR AND LLOYD'S. The mural on the side of Rees' Drug Store, now Arthur and Lloyd's, is seen here. (Author's collection.)

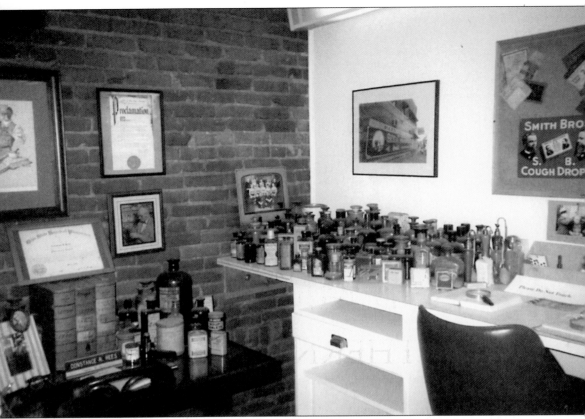

THE PHARMACY MUSEUM, 2007. The Pharmacy Museum is located in the back of Arthur and Lloyd's. (Author's collection.)

Five

THE LAKE SHORE AND MICHIGAN SOUTHERN RAILWAY

On February 18, 1848, the Cleveland, Painesville and Ashtabula Railroad Company was incorporated. The railroad was built from Cleveland to the Pennsylvania state line, where it joined the Franklin Canal Company. The full railroad line officially opened up from Erie to Cleveland on November 20, 1852. The Franklin Canal Company, which was chartered on May 21, 1844, was sold to the Cleveland, Painesville and Ashtabula Railroad Company on June 20, 1854. It assumed all liabilities of the Franklin Canal Company and paid par for the stock. It changed its name to the Lake Shore Railway Company on March 31, 1868. The following year, Northern Indiana, Michigan Southern, and Lakeshore Railway Companies merged to form the Lake Shore and Michigan Southern Railway. The Buffalo and Erie Railway Company was taken on August 16, 1869. The Lake Shore and Michigan Southern Railway now ran from Chicago to Buffalo. In 1914, the Lake Shore and Michigan Southern Railway became part of the New York Central Railroad. The New York Central would be of service for 54 years before it would come to an end on February 1, 1968, when the New York Central merged with the Pennsylvania Railroad Company. They formed the Penn Central Transportation Company, also called Penn Central. The financial system of America was shocked when Penn Central declared bankruptcy after two years of operation in June 1970. Until this time, it was the biggest corporate bankruptcy within American history. In 1976, Penn Central merged into Consolidated Rail Corporation, which is also called Conrail. Conrail was formed from the financially failing Northeast railroad companies and was federally funded. In 1998, Conrail was divided between CSX Transportation and Norfolk Southern Railway. Norfolk Southern received 58 percent of Conrail's assets, and CSX received 42 percent. Many of the eastern U.S. states, including Ohio, are now served by CSX.

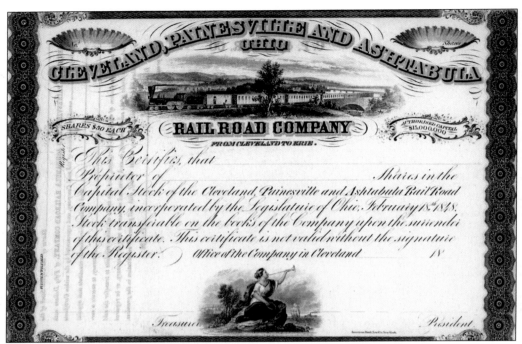

CLEVELAND, PAINESVILLE AND ASHTABULA RAILROAD COMPANY CAPITAL STOCK CERTIFICATE. The Cleveland, Painesville, and Ashtabula Railroad ran from Cleveland to Erie and was incorporated on February 18, 1848, by the legislature of Ohio. (Author's collection.)

THE LAKE SHORE AND MICHIGAN SOUTHERN RAILWAY 1897 ADVERTISEMENT. This advertisement was featured in *Scribner's* magazine. (Author's collection.)

M A. F. R. 100.
GHT BILL.

THE LAKE SHORE & MICHIGAN SOUTHERN R'Y CO.

gnee.. Station,.................................190...

Pro. No...........

To The Lake Shore & Michigan Southern R'y Co., *Dr.*

harges on Freight Way-billed from........................State of................Via................

DATE OF WAY-BILL	NO. PKGS.	ARTICLES AND MARKS.	WEIGHT.	RATE.	CHARGES.
190					
ERIES AND NUMBER OF WAY-BILL					
INITIALS AND NUMBER OF CAR					
CONSIGNOR					
CONNECTING LINE REFERENCE					
ORIGINAL POINT OF SHIPMENT D NAME OF STATE IN WHICH LOCATED					
INAL WAY-BILL NUMBER AND DATE	DELIVERED THE ABOVE PROPERTY	RECEIVED PAYMENT			
		A. E. LA DUE, Agent			
ORIGINAL CAR No. AND INITIALS	CHECK CLERK.	**190**	TOTAL,		

All carload freight shall be subject to a charge for car service of $1.00 per car for each 24 hours detention, or fractional part thereof, after the expiration of 4
rom its arrival.
ORIGINAL PAID FREIGHT BILLS SHOULD ACCOMPANY ALL CLAIMS FOR OVERCHARGE, LOSS OR DAMAGE.

FREIGHT BILL. This Lake Shore and Michigan Southern Railway Company freight bill is dated November 3, 1905. The total amount due is $1.45. (Author's collection.)

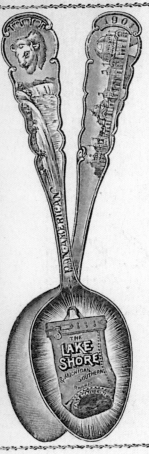

Pan=American Souvenir Coffee Spoon.

Quality Strictly First Grade.

The Lake Shore & Michigan Southern Railway is putting out a very fine quality Pan-American Souvenir Coffee Spoon, made expressly to order by the well known Oneida Community, Niagara Falls, N. Y.

This is not a cheap spoon. The quality is first grade, fully guaranteed by the makers and thoroughly in keeping with the well known reputation of the Lake Shore for reliability and excellence. It is a lasting and beautiful souvenir and a useful one as well.

Price of this souvenir is but 20 cents. Spoons of like quality sell at the Exposition at 50 to 75 cents.

Directions for Ordering :—Spoons will be sent post paid to any address for twenty (20) cents in coin each. While coupon below is made for ordering but one spoon, your order will be filled for any number you desire.

Detach coupon, fill in your name and address plainly and mail direct to factory. If you do not wish to mutilate magazine, spoons will be sent upon receipt of price without coupon.

Lake Shore Pan-American Souvenir Coupon.

The Oneida Community, Niagara Falls, N. Y.—Enclosed find twenty cents in coin for which send me one L. S. & M. S. Ry. Souvenir Coffee Spoon. Address

Name ..

No. ..Street

City .. State

When you have occasion to travel between Chicago, Toledo, Cleveland, Buffalo, New York and Boston, use the Lake Shore & Michigan Southern Ry. It affords the most comfortable and interesting route and the most complete service between above cities.

A. J. SMITH, G. P. & T. A., Cleveland, O.

PAN-AMERICAN SPOON ORDER. This order form for a 1901 Lake Shore and Michigan Southern Railway Pan-American spoon says that the price of the spoon was 20¢ and it was made by the Oneida Community, Niagara Falls, New York. (Author's collection.)

LAKE SHORE AND MICHIGAN SOUTHERN RAILWAY PASS OF GEO. E. MARCHANT, 1894. Geo. E. Marchant was able to travel using his railway pass, which had to be renewed annually. (Author's collection.)

BACK OF THE 1894 LAKE SHORE AND MICHIGAN SOUTHERN RAILWAY PASS. The holder of the railway pass had to assume all risks when traveling on the train. (Author's collection.)

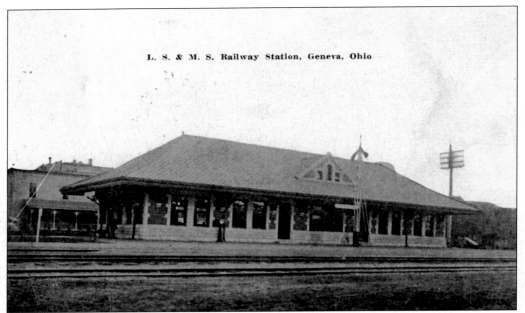

THE LAKE SHORE AND MICHIGAN SOUTHERN RAILWAY STATION, 1912. This depot was built in 1901 at a cost of $8,000 to replace the old wooden depot. It officially opened on Monday, August 12, 1901. It was 100 feet by 30 feet and was made of pressed brick. The walls and ceilings were made of Georgia pine, the floors were made of maple, and the moldings and doors were made of oak. Below is the same depot in a different view. It was torn down in the 1960s to make room for a parking lot. Depot Street can be seen on the right. (Author's collection.)

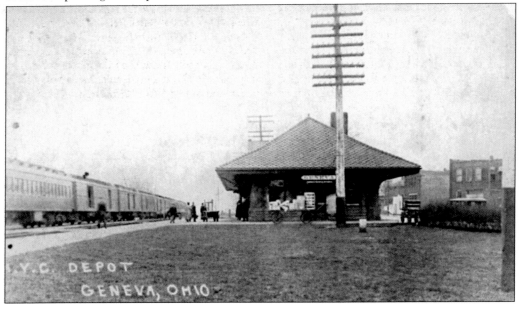

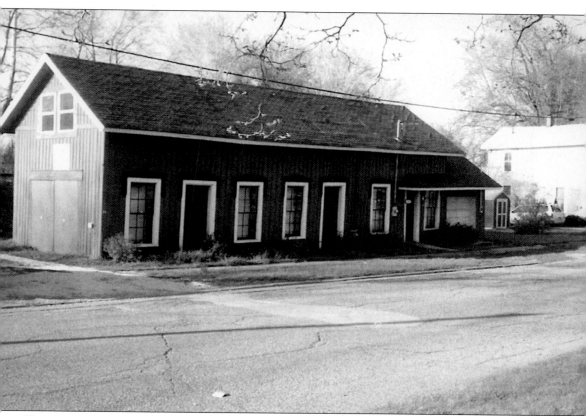

The Original Wooden Lake Shore and Michigan Southern Train Depot, 1999.
On August 2, 1901, James E. Coates began preparing the depot to be moved. The depot was moved to the north side of the railroad tracks, awaiting a purchaser. A couple months later, Edgar Munger purchased the building and moved it to Railroad Street (now Woodlawn Street), where he used it for storage. It still stands today and is located at 99 Woodlawn Street. It was built in the mid-1800s, and a block addition was built on the east side in the 1950s. (Author's collection.)

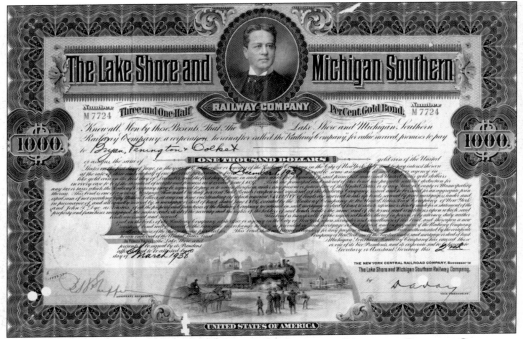

STOCK CERTIFICATE FROM THE LAKE SHORE AND MICHIGAN SOUTHERN RAILWAY COMPANY.
The New York Central Railroad was the successor to the Lake Shore and Michigan Southern
Railway Company. (Author's collection.)

**LAKE SHORE AND MICHIGAN SOUTHERN RAILWAY
TIMETABLE MAP, SEPTEMBER 1903.** The premier passenger
train ran at high speeds from Buffalo, New York, to
Chicago. (Author's collection.)

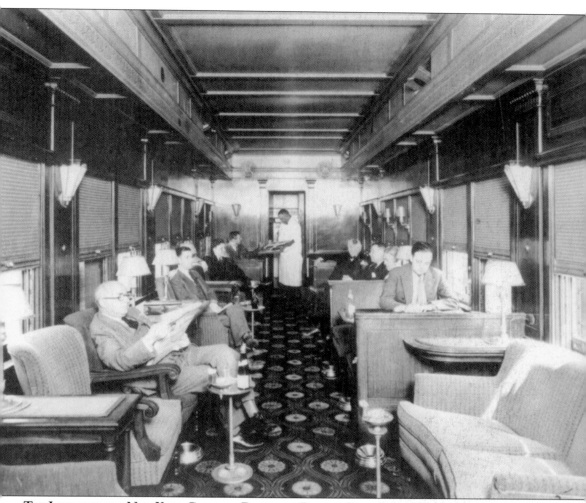

THE INTERIOR OF A NEW YORK CENTRAL RAILROAD PARLOR CAR, 1940S. The waiter is attending to one of the guests as the others relax, read newspapers, or smoke. (Author's collection.)

ACROSS AMERICA, PEOPLE ARE DISCOVERING SOMETHING WONDERFUL. *THEIR HERITAGE.*

Arcadia Publishing is the leading local history publisher in the United States. With more than 3,000 titles in print and hundreds of new titles released every year, Arcadia has extensive specialized experience chronicling the history of communities and celebrating America's hidden stories, bringing to life the people, places, and events from the past. To discover the history of other communities across the nation, please visit:

www.arcadiapublishing.com

Customized search tools allow you to find regional history books about the town where you grew up, the cities where your friends and family live, the town where your parents met, or even that retirement spot you've been dreaming about.